To Donna — my Facebook pal,
All good wishes!

Bruce Jarmabrandt

WHAT PEOPLE ARE SAYING

We've all heard that given enough time, a roomful of chimps banging on computer keyboards will produce a Shakespearean play. Bruce proves that, in the art world, it only takes one.

--Dr. H. David, therapist

People who send me manuscripts invariably say they know how busy I am—but they don't really seem to. I get three or four manuscripts a week. I don't read them. I haven't read a novel since **Lorna Doone***. I have all I can do to read an hour of The New York Times every day. I look at my mail but can't say I actually read all of it. I'm not clear what you want. Send your material to an editor...If it's any good, they'll print it.*

-- Andy Rooney, writer and commentator,
in response to an endorsement request from the author

Bruce is the art world's Robin Williams—well, except for Robin's wild ad-libbing and that crazy shirt he always wears. And Bruce doesn't have a microphone... or a stage. Okay, so he's not like Robin Williams—but he's still a damn good artist.

--Al Markowitz, college friend

Through an unhappy childhood, lousy high school experiences, difficult college years, a bad marriage, poor career choices, serious injury, and the loss of loved ones, there has been one constant in my life—Bruce Garrabrandt. The guy is an albatross.

--D.L., a lifelong friend (who prefers to remain anonymous)

George Bernard Shaw once said, "Without art, the crudeness of reality would make the world unbearable." But, then again, Shaw never saw Bruce's work.

--James Isacson, the artist's 6th grade teacher

Bruce comes to the post office to mail packages every day. I guess lots of people are buying his artwork. Frightening, isn't it?

--Maureen Witmer, Postmaster, Terre Hill, PA

Bruce Garrabrandt is a leech! He latches on to innocents in nature, applies his parasitic pencils to these hapless creatures and "draws out" the juicy parts for all to see. He's an artistic menace to the animal world.

--Dr. Diane Curry and Dr. Michael Franco,
zoologists

Living next door to Bruce in a dorm throughout college made me eyewitness to his formative experiences, an observer of early events that shaped his artistic sense. I recall none of these. I do remember that he played Bing Crosby records too loudly, and he once had all his underwear sewn shut by an irate co-ed.

--Duane Siders, college friend

I'm still in therapy and would rather not comment at this time.

--C.V., a former girlfriend

Growing up with Bruce taught me the value of a good sense of humor, especially during difficult times, such as—well—growing up with Bruce.

--Gayle Garrabrandt, the artist's sister

I'm glad Bruce finally accomplished something. Even if it is stolen, plagiarized, or an otherwise cheap imitation of someone else's hard work, at least that shows some initiative. I've never worked with anyone so prone to goldbrick. I'm calling the police. Enough is enough.

--Howard Nixon, former co-worker

Bruce's new coffee table book is just great! It fits perfectly under the short leg of my coffee table, and has stopped that annoying wobble.
Seriously, looking at Bruce's drawings reminded me of my childhood, when try as I would, I could not learn to draw. So I took up photography and became quite accomplished. Bruce, I have a very good spare camera I'd be happy to give you.

--Randy Stewart, photographer and friend

Only after Bruce's repeated pleadings did I agree to provide an endorsement for his book. Frankly, it's been worth it just to end his incessant whining. People have been known to emigrate to avoid hearing it.

--Gary Frischman, college friend

My friendship with Bruce goes back nearly 40 years. I've seen him at his worst—because that's pretty much his best.

--Cathy Vitale, ostensible friend

One of Bruce's inspirational mottos is "Don't be afraid to look silly"— and he lives up to it better than anyone I know.

—Monica Wolf, artist and friend

THIS BOOK HAS
BEEN INSPECTED
AND NO FLAWS
WERE FOUND
(WHICH IS MORE
THAN CAN BE SAID
FOR THE AUTHOR)
USDA

THE MILKY WEIGH

...and other artistic anomalies

BRUCE S. GARRABRANDT

Other books by Bruce Garrabrandt

The Power of Having Desire

Cattle Drive (And 153 Other Random Acts of Artistic Nonsense)

My Name Is On The Deed...But The Cats Own The House

Make Yourself Ageless (366 Ways to Keep Growing Young)

Life Lines (Thoughts to Hold onto Through Bad Times and Good)

to Gary Larson

Your innovative, timeless cartoons continue to make me smile.

ACKNOWLEDGEMENTS

Special thanks to Jeffrey White, of White Custom Media, for bringing yet another collection of my art and thoughts to literary life.

I am also grateful to Gayle L. Garrabrandt for her helpful editorial suggestions in preparation of the final manuscript.

Sincere thanks go to Steve Shay at Cornerstone Graphics, who skillfully scans all of my original art images to disc.

A bushel of appreciation goes to Hasbro for the use of its perennial Mr. Potato Head in my playful, parody drawings. Working with him made me feel eight years old again.

INTRODUCTION

"Where did you go to art school?" people often ask me.

"I didn't," I tell them. "In college, I majored in pre-unemployment—I was an English major."

Having no interest in journalism or teaching, I decided, after graduation, to start a free-lance writing career, but none of my work got published. First I tried my hand at poetry. I'll share with you one of my favorites:

I could love you, as April flowers love rain,
But I don't.
I could hold you, as leaves hold morning dew,
But I won't.
With the graceful movement of a startled deer,
I'm out of here.

That's an excerpt from my first, unpublished book, **Love Poems for the Non-Committal**. I also wrote a lot of children's stories back then. Here's just a sampling:

The Little Engine That Could, But Got Sold For Scrap Metal Before It Had A Chance To
Green Eggs And Ham And Salmonella
Three Little Pigs On A Spit
Lassie's First Heat
Rapunzel's Scalp Condition
Cinderella's Bunion And The Shoe That Wouldn't Fit

No publisher showed interest in any of them. Go figure.

That's when I decided to start a business as a professional artist, marketing my work at juried arts festivals, at galleries, and at gunpoint. This has been my career for more than twenty-five years, and business is good. I allow myself certain luxuries now—such as three meals a day and indoor plumbing. I also toyed with the idea of buying one of those large-screen TVs, but decided to save my money and just sit closer to the set.

I hope you enjoy this latest collection of "random acts of artistic nonsense." There will be more silliness to come. (I can almost hear my wife groaning.)

Bruce Garrabrandt
Lancaster County, PA

Mr. Potato Head's Worst Nightmare

Congress In Session

Bad Suspense Films

"You look so familiar to me."

Penguin Pick-Up Lines

Dyslexic Yogi

Cariboo

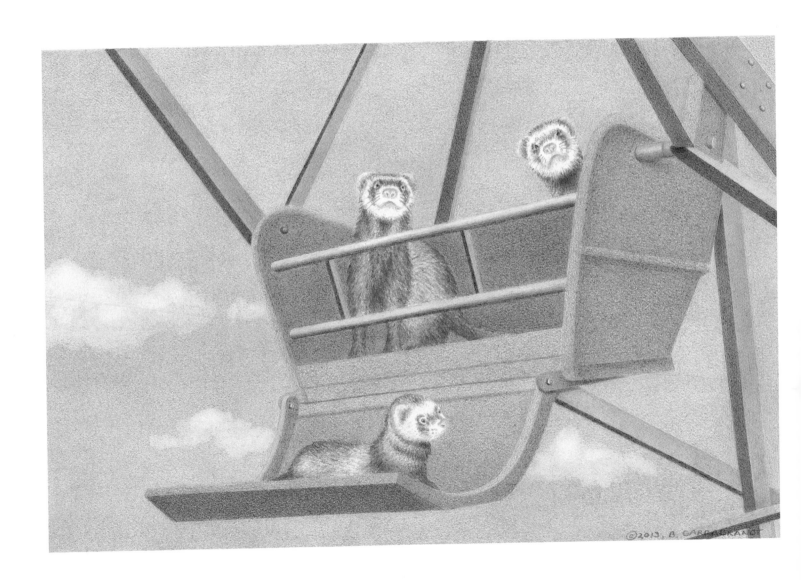

Ferrets Wheel

Top 12 Truths of Life

"Write what you know about," my English teachers always told me. "Write what you know about well." So I did, and discovered that readers weren't exactly hungry to learn how to balance a yardstick on their toes, or how to sing along to Sinatra records and hold the notes as long as Frank does.

Then one day, several years ago, I sat waiting in my car while a policeman sat in his car, writing me a ticket. There was a Post-It pad on the seat next to me. Frustrated, I scribbled onto it: "Police cars are never around when you're driving under the speed limit." I pulled the note from the pad and stuck it to my sun visor. Suddenly, more of life's truths began floating through my mind:

"An adhesive bandage comes off when you want it to stick, and sticks when you want it to come off."

"If your name can be misspelled, it will be—in more ways than you thought possible."

By the time the policeman returned to my car with the ticket, my steering wheel and dashboard were blanketed with little yellow squares of paper, each containing a universal fact of life. I turned to the officer, beaming.

"I found it!" I said.

"Found what?" he asked.

"My niche," I said. "'Write what you know about well,'" my teachers told me. "Write what everyone knows about well!"

The policeman stared at me for a moment, and then said, "How about getting out of the car and walking a straight line for me?"

In the months that followed, I became what writer Henry James once described as "one of those people on whom nothing is lost." The number of Post-It notes grew wildly, clinging like yellow moss to my walls, desk, refrigerator—everything. Drawn from more than fifty years of observation, frustration, and confusion, they became a massive collection of everyday life truths.

I'd like to share with you what I've discovered to be the top twelve truths of life:

12. Women find fault. Men can't find anything.
11. The shortest distance between two points is never found by anyone working in government.
10. You'll only find a needle in a haystack when you're looking for a place to sit down.
9. If you escape anything by the skin of your teeth, you're not brushing properly.
8. To be on the safe side, never assume there *is* a safe side.
7. If your eyes are bigger than your stomach, you should contact a physician immediately.
6. All food tastes the same if you cook it long enough.
5. You never make a fool of yourself in private.
4. People with bedroom eyes usually have structural flaws throughout the rest of their house.
3. Time and tide wait for no one, but mosquitoes will follow you anywhere.
2. It is too late for a career change when the police have you surrounded.
1. Don't look for a quiet place where you won't be disturbed. All human beings are disturbed.

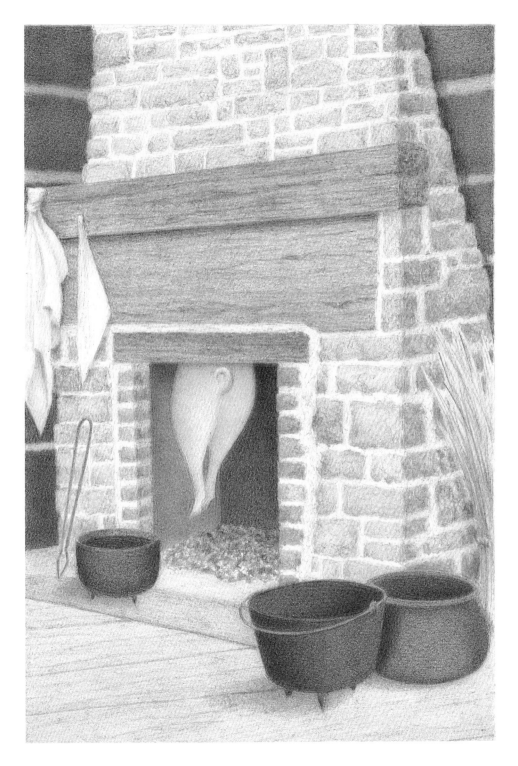

Swine Flue

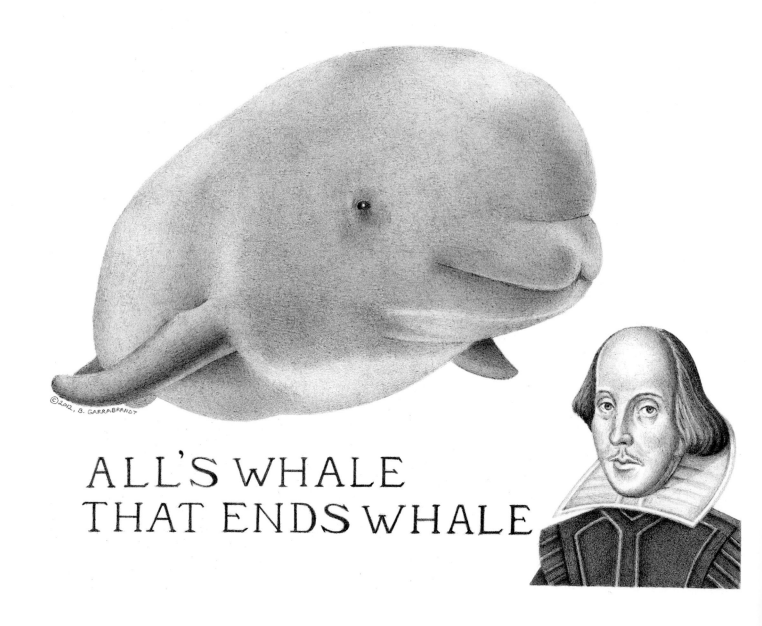

ALL'S WHALE
THAT ENDS WHALE

Great Fish Stories

Mr. Potato Head's 2nd Worst Nightmare

Night Lights

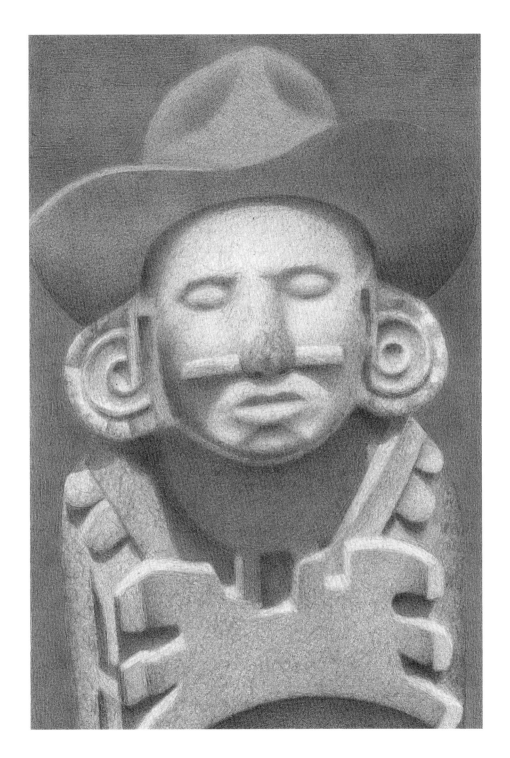

Ancient Aztex

Bad Indian Puns

On Family

"Did you come from a funny family?" people often ask me.

"No," I tell them, "we were serious, formal people—so formal, in fact, we always dressed for dinner. Breakfast and lunch we ate naked, but for dinner we dressed."

I grew up with a brilliant father. My dad spoke sixteen languages—but he spoke them all at the same time. We never knew what he was talking about.

My mom was a homemaker, a typical 1950's mom. She loved to cut recipes out of magazines, but her meals always tasted oily and metallic. We found out later that she was subscribing to *Popular Mechanics*.

There was a time when I thought genealogical research would be a fun hobby, until I learned that our family tree was a Dutch Elm. My ancestors came to this country looking for asylum. They were sent to a mental hospital.

My grandfather was a Lithuanian square dance caller, which was odd, since our family isn't Lithuanian. My grandfather was born in New Jersey. Needless to say, life was always something of a struggle for him. I recall that, in later years, he suffered from prostrate trouble. Not prostate—prostrate. Whenever he stood up, the problem went away.

My great-grandfather was a Northern soldier in the Civil War. He fought at both Chancellorsville and Fredericksburg—two severe Union defeats. To what extent he was personally responsible for these losses, we'll never know. He was mustered out of service on June 30, 1863, just one day before the battle at Gettysburg. It was good timing, or we might have lost that one, too.

Another interesting relative was my great-uncle Jake, a professional hairstylist. Sadly, he was psychotic. At one point he joined with the voices in his head to form a barbershop quartet, trying to create a vaudeville act for the group, but it didn't go anywhere. He was the only one who could appreciate how good the group sounded. Uncle Jake was bitten with the show business bug. He took all of his money and went to Hollywood to become a film producer, but his career was short-lived. It was the 1920's. Uncle Jake tried to bring opera to the silent screen.

My cousin Ned was the inventor in our family. He designed the very first "white noise" machine. It played the soundtrack to a KKK rally.

I'll never forget my Aunt Sophie, a lovely woman, but severely dyslexic. Aunt Sophie eventually alienated herself from all friends and neighbors. Whenever they went on vacation, she would take in their plants and water their mail.

I have one brother and one sister. He's a lawyer and she's a court reporter. I tell my mother that someday I'll be the defendant. That way she can boast that all of her children are involved in the judicial system.

Beef au Jus

Tie Chi

Mr. Potato Head Reads An Eye Chart

Bavarian Hops

Pigs Do Have Wings

Boardoe Wine

Pet Peeves

It was Emerson who told us, "Nothing can bring you peace but yourself." How true that is. But the trick is learning how to keep our inner tranquility in the face of life's many challenges.

I'm not talking about the major crises we all deal with in the course of our lives. I think most of us are equipped with the fortitude to handle these things. It's life's small irritants— the daily frustrations and annoyances—that slowly, steadily chip away at our mental foundation until they finally cause our peace of mind to collapse.

Here's just a sampling of my personal pet peeves:

What's with the fine print in newspaper and magazine ads—all of those disclaimers you can read only with an electron microscope? Hey, advertisers! If you have something to say, say it so we can see it.

Use of the death penalty should be expanded to include anyone involved in the manufacture of wind chimes.

Nobody driving anywhere is interested in what you or your bumper stickers have to say.

Christmas ornaments generally outnumber hanging hooks two to one.

The strongest bond formed by any glue is that created between the glue cap and the glue tube.

Darkness causes flashlights to fail.

A napkin placed in your lap somehow finds its way to the floor just moments before you go to reach for it. All napkins harbor a secret desire to be throw rugs.

The doors on your new car beam radio messages to car doors everywhere, saying "ding me."

No two matching socks ever wear out at the same time.

If we want to keep peace of mind, I think what helps is a healthy dose of resignation. Some wise observer once said, "I was always complaining about the ruts in the road until I realized that the ruts *are* the road."

A WEIGH IN THE MANGER

Failed Christmas Carols

Sea Cows

Great Fish Stories

©2008, B. GARRABRANDT

Bi-Polar

Bad Adventure Films

Mr. Potato Head's 3rd Worst Nightmare

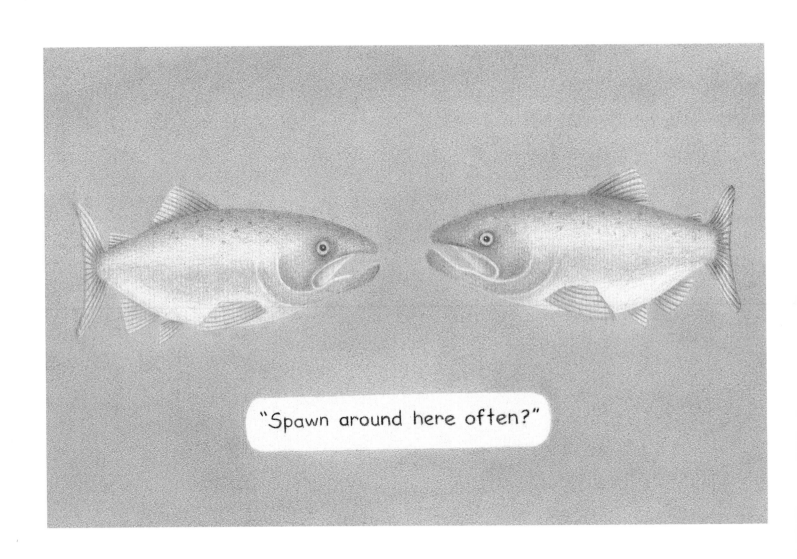

Fishing Lines

"Your breath is offal."

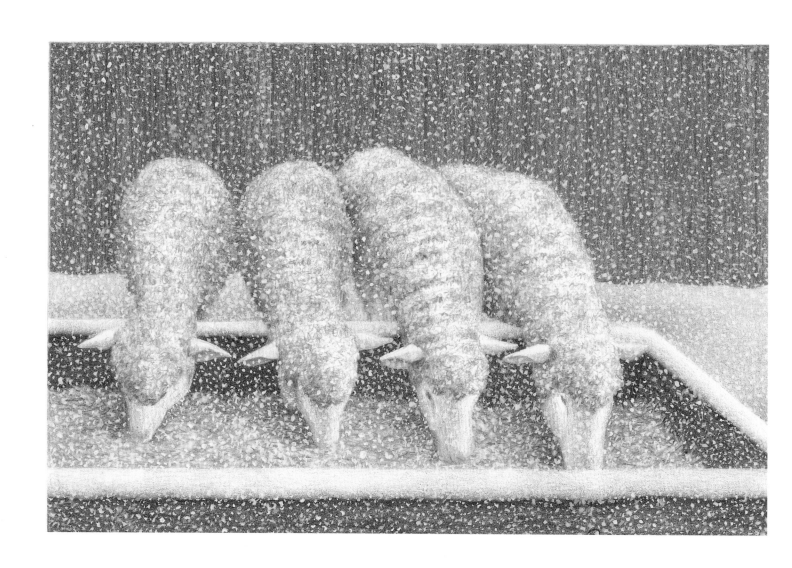

All-You-Can-Eat Baahffet

A Christmas Chronicle

Drawings like *All You Can Eat Baahffet* are among my favorites, because they put me in the mood for winter. I love snow. Whenever I wake to see the ground blanketed and large flakes falling hard and fast, that part of me that is forever ten years old gets excited and thinks "no school today!"

Covered in snow, our small town in Lancaster County, PA looks like the proverbial postcard picture of winter in the country. Most homes along our Main Street are over a century old. Before the plows appear, more than one Amish neighbor will trudge to the barn and hitch his horse to an ancient sleigh, strap on two sets of bells, and enjoy a leisurely drive along Main Street and through the countryside. The horse's hooves and sleigh runners are silent in the snow. The only sound heard is the jingle of sleigh bells. For a brief time our town is a Currier and Ives painting come to life.

For me the sight of snow also brings with it warm memories of my youth and the Christmas season, with all of its family traditions. Beginning in November, Christmas issues of women's magazines lay strewn open around our kitchen, dog-eared and covered in flour while Mom baked at a frenzied pace. Like a crazed and hyperactive Donna Reed, she produced tray after tray of cookies, candies, breads, and fruitcakes for family and friends. She wore her apron like a uniform from Thanksgiving to New Year's Day, never taking it off, not even to sleep. If she slept at all, it was while leaning against the oven, waiting for the timer to go off.

The day before Christmas was full of traditions in our house. The following scenes and dialogue were repeated, verbatim, for years:

"The tree is crooked," said my mother.

"Which way should I move it?" Dad asked from behind the tree.

"That way."

"*What* way?" I can't see a thing back here."

"Left," said Mom.

A tree branch lashed his ear at that moment and he didn't hear her clearly.

"Left?" he asked.

"Right," she replied.

"Okay." He tilted the tree to the right and jammed it down onto the prongs of the tree stand.

"What are you doing!" yelled my mother. "It looks worse now!"

"I did what you told me!"

"I said to the *left*."

"You said *right*."

And so on. Our annual tree ritual was under way, replete with maneuvering misunderstandings, branch-pruning disputes, and a host of trimming tribulations.

Mom always put the family into a festive mood by loading a stack of Christmas albums onto the turntable. No one knew less about the proper handling of record albums than my mother. A primal, destructive urge gripped her whenever she got hold of one. She stamped her fingerprints into every groove, dragged the tone arm savagely across the record surface, and stuffed two or three albums into a single album sleeve. Through years of misuse, all of our Christmas records sounded like chestnuts roasting on an open fire.

"Jesus Christmas!" From upstairs my father sang out the Lord's name, full of the holiday spirit as he crashed his head against an attic beam for the third time that day.

"Go help your father bring down the decorations," my mother ordered me.

I headed for the stairs and stumbled over our dog, Buddy, who had leaped in front of me, hoping I was going to feed him. Buddy had just eaten, but he was senile. He remembered nothing. With all the family activity and commotion, Buddy figured it must be time for dinner. He ran continual laps from his empty food bowl in the kitchen to his family in the living room, giving us all searching, expectant looks before dashing back out to the kitchen.

I'm dreaming of a white—of a white—of a white—

Bing Crosby's voice remained stuck in a demented croon on the turntable. My mother gave the tone arm a

whack, sending the needle skidding across the record grooves.

Down from the attic my father and I carried boxes of Christmas decorations into the living room. My sister began clawing at a gnarled ball of tree lights.

"Be careful with those," Mom cautioned. "Tree lights can short out and be a fire hazard." That was such an odd comment, coming from a holiday pyromaniac. During the Christmas season her obsession with fire got the best of her. Mom loved to light candles. Now, still early in the afternoon, she already had candles burning in glass bowls, candles flickering in ceramic holders and metal candle stands, candles on plates and jammed into the mouths of empty wine bottles—dozens of candles in all shapes and lengths. The house reeked of bayberry, balsam, and pine. Supplemented with a spray air freshener of evergreen scent, these fumes combined to give the entire family chronic lung ailments.

My sister and I unpacked fireplace decorations and adorned the mantel with Styrofoam carolers dressed in green and red felt, their open mouths forever forming the letter "O" as they sang in mute harmony. They huddled together in drifts of Plaster of Paris snow that had yellowed with age, creating the impression of carolers afflicted with bladder control problems.

Mom had trouble putting up the stockings. Years of pushing thumbtacks into the mantel had reduced the wood to mangled pulp. The only way to hang our stockings by the chimney with care was to drive them in with railroad spikes.

May your days be merry—be merry—be merry—

Mom snapped Crosby out of it with a spastic karate chop to the turntable that sent him flying into the middle of his next song, where he was joined by the Andrews Sisters.

Only when Dad finished stringing the mauled tree limbs in lights did Mom stop to survey his work. "You missed a row," she said, "—and can't you hide the wires? I hate when the wires show."

"Balls," mumbled Dad.

"No ornaments yet," said Mom. "Not until you fix the lights."

It's beginning to look a lot like Christmaaarrrrr—

Crosby's voice drawled to a stop the moment my father plugged in the tree lights.

"God Almighty!" Dad proclaimed, on his way to our circuit box in the cellar. Little annoyances never kept

him from expressing his reverence for the season.

The doorbell rang. Grandma and Grandpa had arrived. Grandpa was always thirsty after his long drive in from the country. He walked directly to the eggnog bowl and spiked a cupful with brandy.

"You're just in time to help with the ornaments," said my mother, grabbing hold of Grandma's arm to keep her from diving headlong over the dog as he raced by on his way to the kitchen. Buddy was certain these two elderly people had come to feed him.

rrrraaassss, everywhere you go…

Bing came to life once again on the turntable, and the tree lights blinked gaily as my father returned from the cellar, carrying his version of the yule log. It was one of those pre-packaged cylinders made from compressed sawdust mixed with carcinogenic chemicals and marketed to people like my father, genetically incapable of setting fire to real pieces of wood placed in a hearth. A "Blaze-O-Flame" log was designed to ignite the moment a match was struck anywhere within ten feet of it. A single log would burn all evening. Eerie green and pink flames created that special holiday glow in our fireplace and sent fumes up the chimney toxic enough to kill Santa instantly.

Trimming the Christmas tree always put my mother in a sentimental mood. Many of our ornaments were family heirlooms with special meaning for her.

"This one you gave us," she said to my grandparents, picking up a tiny cloth Santa Claus perched inside a wire wreath.

"Yes," said Grandma, "we put that ornament on our first Christmas tree, the year we were married." She frowned. "What's happened to him?"

"Buddy got hold of Santa a few years ago," my mother explained. Santa's tiny head had been gnawed off. One arm hung limp and mangled. Various wires poked through his worn and faded red suit. He looked like something out of a horror film, so my mother placed him deep within the tree branches where he wouldn't startle holiday visitors.

By this time our house was buzzing with Christmas energy—or maybe it was just the overloaded electrical circuits.

"You made this ornament in school," Mom said to me. She held up my pathetic Christmas creation from the second grade. It consisted of elbow noodles glued together in a clump, attached to a string and spray-painted gold. It was grisly.

Our tree trimming was always followed by the ceremonial Family Christmas Picture, taken by Mom with our home movie camera. My mother's movies contained little movement. We were herded together into a cramped knot in front of the tree, blocking it completely. She filmed the family standing there looking rigid and ridiculous, framing us either from the waist up or from the neck down. Our bodies were never captured in their entirety on celluloid.

We have no movie memories of what Dad looked like when we kids were small. Mom, determined to get us into the picture, inevitably cropped off Dad's head. For all I know, that wasn't even my father upon whose knees we were seen bouncing.

At last we brought out Christmas gifts into the room and piled them under the tree.

"Look at all those presents!" said my grandmother. "Santa has been good to us."

"We went overboard again this year," said Mom. The reason our national economy was so healthy during the 1960's was because this was the decade in which my mother made her largest number of gift purchases.

"In our day we were thankful to find an orange in our stocking," said Grandpa, downing his fourth cup of holiday cheer. This was my grandfather's solitary Christmas reminiscence, his lone comment regarding seasons past.

Only Grandpa slept well on Christmas Eve. No one else could enjoy a long winter's nap, and no visions of sugar plums danced in our heads. My grandfather snored. His was a loud, long, strangulated snore. To me it sounded as though Santa, driven mad by the noise of Grandpa's rattling adenoids, had sneaked into the old man's room and was slowly choking the life out of him. I lay in bed and wanted to believe, "Yes, Virginia, there is a Santa Claus."

We all came downstairs groggily the next morning. Slumped into chairs around the Christmas tree, eyes only partially open, we proceeded to claw the wrapping off our presents.

Christmas gifts were chosen with great care in our family, each one tailored to the tastes of the individual, every gift a thoughtful reflection of the recipient's personality. We gave and got neckties that had no chance of complementing any other article of clothing, fitted shirts that did not fit, argyle socks of strident colors, and gloves. Always there was a new pair of gloves. The left glove would be missing by January 15th and the right glove would be stuffed into a bureau drawer—next to the eight other right-hand gloves from previous Christmases.

Opening presents in our house was a special event. It was a time to remember those we loved, a time to realize how much we had to be thankful for, a time to decide when we should get to the mall the next day to avoid lines at the Customer Returns counters.

Christmas afternoon we gathered around the dining room table to join in our finest holiday tradition—The Dinner Binge. We were united as a family in our unspoken but faithful devotion to the Christmas Glutton's Pledge:

I promise, in the sight of God and man, to gain more pounds of holiday fat in the next two hours than I will be able to lose in the next two months. I will soar beyond every minimum daily requirement of fat, protein, and carbohydrate, to reach food intake levels high enough to add tonnage to my frame and astound all those who know me. This I will do in God's name I know not why.

And a good gorge was had by all.

Bowls and plates and platters of food passed around our table so quickly that turkey, turnips, stuffing—everything edible—blended into one massive caloric orgy that consumed us as we consumed it.

"More potatoes?"

"Why bother asking?! Pass the bowl!"

"I'll have some more cranberry sauce!"

"Keep it moving!"

"Do I need to warm the gravy?"

"Are you kidding? *What* gravy? That was gone an hour ago!"

We celebrated our abundance with a full expression of feeling, later feeling too full to express our discomfort. We sat in silence, unable to move, faces flushed, hearts pumping madly to handle the sudden, excessive addition of abdominal weight. With slow and deep breaths we tried to will our digestive systems to pick up the pace a bit while we prayed, "God help us all, everyone."

Much later, when the family was once again mobile and the dishes were washed, dried, and put away, my father announced our evening Christmas ritual:

"Let the games begin!"

One year Santa Claus brought us the home version of *Password*. Pictured on the box were a happy Mom and Dad, Junior and "Sis" playing the game together, laughing and holding hands. They were obviously having the time of their lives. They were nothing like our family.

Grandma and Grandpa, having lived through too many Christmas games gone bad, wisely said goodnight and went to bed.

We sat at our card table, Dad and I teamed against my mother and sister. Clues were given and passwords guessed. The tension mounted. No one held hands or laughed. Peace on earth, goodwill to men—but not in this house, not during *Password*.

"You're taking too long to answer!" my mother complained. "You don't get this much time on the T.V. show!"

"We're not on the T.V. show," Dad argued. "Those are professional contestants."

"Oh, you give me a pain," said Mom.

"And you give us all a headache," said Dad. Christmas was always a time of giving in our house.

"The game should have time limits," my sister whined.

"Let's see what the directions say about it," said my father. He began to read the game instructions aloud… all of them. "Each team consists of two players…"

"We know that!" groaned my sister.

"One member of team 'A' goes first by giving a clue…"

"I won't play if you're going to continue like this," Mom warned.

My father ignored their protests and went on reading aloud in a calm, deliberate tone. He paused after each paragraph to say, "I see nothing in these directions about a time limit," then resumed reading. The filibuster worked.

"Okay—forget it!"

"Can we just *play*, please?"

"Let's get on with the game!"

The game that year continued but was short-lived. My father studied the next, fateful password. He looked

up at me with a steady, meaningful gaze. "Fabric," he said confidently.

"Cotton," I offered. That was not the password.

Mom turned to my sister. "Checkered," she said.

My sister thought for a moment. "Plaid?"

"No," said Mom.

Dad was excited now, certain that I would put these clues together with his next one and guess the password. He leaned forward. "Dress," he said.

A word immediately took form in my mind that I believed was the answer, but I was unsure of the spelling. The word seemed right, though. I blurted it out: "Bingham!"

Shrieks of laughter erupted from my mother and sister. Dad stared at me in angry disbelief. Mom repeated the last clue to my sister: "Dress."

"Gingham!"

"Yes!" said Mom. Mother and daughter clapped their hands in triumph.

My father looked at me as if to say, "How could I have fathered anything so dumb as this?" He was incredulous. "*Bingham?*," he repeated. "I gave you good clues. What the hell is 'bingham?'"

"Bingham Crosbyham?" my sister offered.

"I don't think it's funny," said Dad. "We should've won that."

"Sorry, Dad," I said quietly.

"It's only a game," said Mom.

"Well he should play it to win!" bellowed Dad.

Silent night, holy night, all is calm, all is bright…somewhere, perhaps—but not in our living room. The game was packed away after that, and everyone headed upstairs for bed. Another Christmas was over.

My mother loved romantic traditions. She read about them in stories of old-fashioned Christmases and tried to make these rituals her own. Her attempts usually failed; nevertheless, we did create our own romantic traditions. Loving family rituals managed to mix in with the family chaos. Affection accompanied the arguments. Members of my family never practiced special behavior during the sacred holiday. They were themselves. That was special enough.

Lawn Ornament

Cowbernet Sowvignon

A Streetcarp Named Desire

Great Fish Stories

Military Coo

"Are your brakes squealing--or is that you?"

Mr. Potato Head's Tanning Salon

World Piece

Marital Musings

I'm something of an authority on marriage. I've done it twice. My first wife I made miserable, but my second wife—well…I just annoy and irritate her. That's *some* improvement, anyway.

In a nationwide survey of married adults, 43% identified "lack of communication" as the number one problem in marriage; however, among couples married over 30 years, 87% of these people said the secret to a lasting relationship is to never listen to your spouse at all.

I'm kidding, of course. Communication in marriage is essential. And communication is enhanced when we make positive statements about our partner. You can build self-esteem in your mate by offering praise whenever possible. Even the most difficult spouse has at least one trait we can say something positive about. For example:

"I'm truly impressed by the strength of your voice when you scream at me."

"I love the way your face turns red when you fly off the handle like this."

"Your hands always feel so nice around my neck."

Statements like these convey appreciation, acceptance. Try to say them before your partner has a chance to choke off your wind.

Lack of communication has been identified as the number one marital problem. Other major causes of conflict are money, sex, and in-laws. (Consider the marriage doomed if you're having sex with an in-law for money.)

People often ask me, "Bruce, is a happy marriage feasible? And, if it is, how *do* you fease it?"

Well, I tell them, even the most compatible marital partners need occasional solitude. Wanting to spend time alone is a natural human urge. But wanting to spend time alone, under an assumed name—in a different

state—may signal a problem with the relationship. Here are seven more warning signs that your marriage could be in trouble:

--He stops doing those thoughtful little things he used to do—like coming home at night.

--You ask what would make sex more exciting for her, and she says "separate vacations."

--You tell her you want to try a new position, and she offers to type your resumé.

--Your partner stops exhibiting mood swings and starts resenting you with consistency.

--She says she needs more harmony in her life, so she's sleeping with a barbershop quartet.

--Touching and stroking are replaced by pushing and shoving.

--Your partner invites you to take a romantic stroll through the woods, and insists on bringing a shovel. (Introducing a little mystery to the marriage is good, but not when that mystery involves making police discover where you hid the body.)

Through the years, I've read countless books, articles, and quotes on marriage. Here's my favorite comment on the subject: "Men marry thinking women will not change. Women marry thinking men *will* change. They're both wrong."

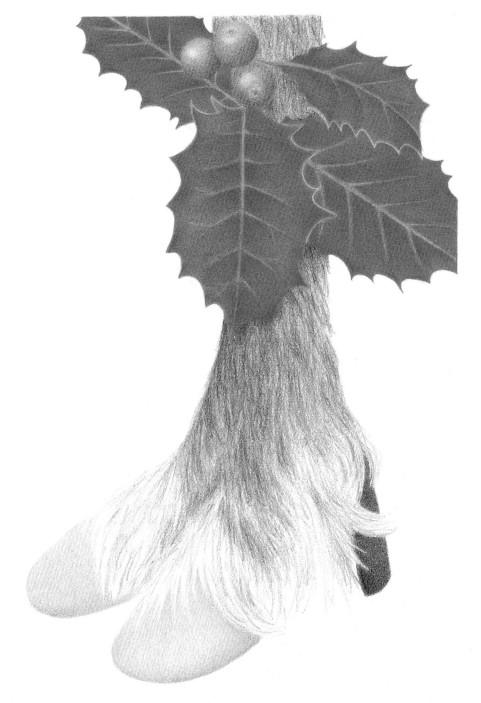

"Hoof Yourself A Merry Little Christmas"

Failed Christmas Carols

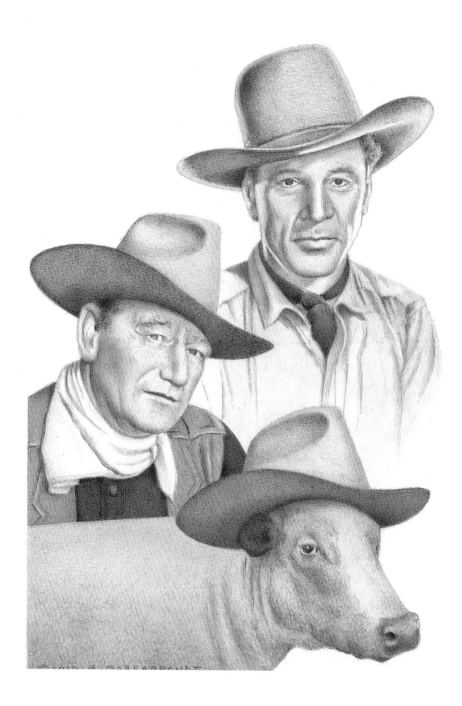

Cowboys

©2011, B. GARRABRANDT

Sleep Tight

Minewet

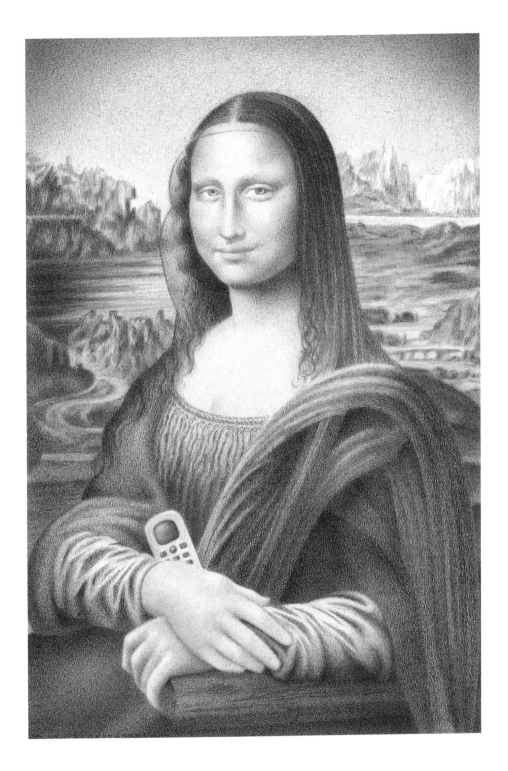

Phona Lisa

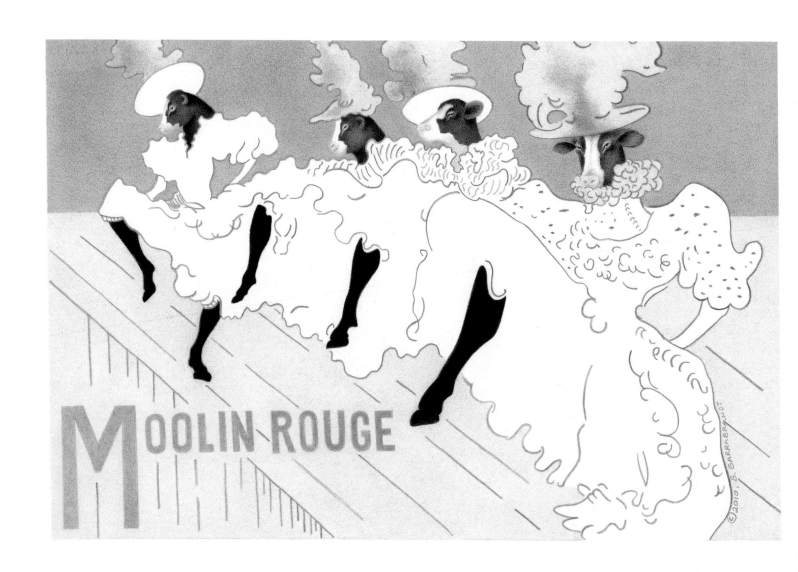

At The Moolin Rouge

On Dancing

We are all created with different personalities and temperaments, to be suited for various roles in life. Some people are born leaders, others are natural peacemakers, some are society's creative builders. I've thought a lot about my personality and life purpose. God seems to be telling me, "Keep out of the way and don't make any trouble. Just stay at your easel and draw. And for My sake, don't be so clumsy or you'll stab yourself with that pencil."

I've managed to lurch and fumble my way through more than fifty years without serious injury, but my body was obviously designed for use by someone else. It doesn't fit me properly. Nowhere is this more evident than on the dance floor.

Let it be known that you don't like to cook, and few people raise an eyebrow. Announce to the world that you never play chess, and the world accepts this. Mention your inability to carry a tune, or the fact that you don't participate in sports, and others shrug and remark, "That's okay—we've all been given different gifts."

But tell people "I don't like to dance," and they slowly back away from you with suspicious stares. "You don't like to *dance*?" they ask in disbelief, as if you'd casually told them "I don't like to breathe."

"But *anyone* can dance!" some woman is always assuring me. "You just go along with the rhythm."

"When the rhythm starts I just go along home," I tell her.

"But dancing is easy!" the woman insists. "Here—let me show you." At this point she yanks my arm to pull me out of my chair, onto the dance floor. I struggle to stay seated. If she is muscular, she manages to drag me, still clinging to my chair, halfway across the room before it finally hits her that "Gee! He really *doesn't* like to dance." She drops my arm and looks at me, confused. She shakes her head and walks away, keeping a safe distance between herself and me, The Social Freak, for the rest of the evening.

I'll tell you how bad I look on the dance floor. People rush over and try to cram their wallets into my mouth. They think I'm having a seizure.

My aversion to dancing began in grade school. Our principal thought it a good idea to force the boys' and girls' gym classes together on the auditorium stage once a year, to perform square dancing routines.

"It allows the children to enjoy a wholesome recreational activity," he explained. Needless to say, boys and girls of elementary school age had no desire to share recreational activities of any kind—even *un*wholesome ones.

A rotund woman in a frilly, checkered dress came to our school from God-only-knows-where. She carried a purple, portable record player and a stack of worn square dance albums. With an irritating twang she yelled instructions to us over the music while we staggered and twirled in clumsy circles around the auditorium stage. We dropped the sweaty hand of one overheated partner to bump into and grab the clammy hand of another. All of us were repulsed by the act of actually touching someone of the opposite sex, but we endured it. We stumbled and strained to follow the confusing instructions barked at us by the mammoth woman in the frilly dress. Thank God this ordeal happened only once a year.

Another early exposure to dancing occurred in the seventh grade. Our junior high organized monthly after-school dances. The girls danced with each other while we boys clustered around the refreshment table to scoop orange rinds from the punch bowl and wrap them across our front teeth. We pushed, shoved, and clowned around, making every effort to impress the girls by acting like jerks. We did everything but actually ask a girl to dance.

All through adolescence I successfully dodged my mother's repeated attempts to teach me to dance. Teenage boys didn't learn to dance by practicing with their mothers. That bordered on incest.

"Get with it!" coaxed Mom. She turned on the radio in our living room and began dancing to the music. "Can't you feel the beat?" she asked.

"No," I said—and meant it.

"What's wrong with you? You should *want* to dance."

"I'm dancing-disabled."

She turned to my father. "Make him dance," she told him.

"Leave him alone if he doesn't want to dance," he said.

Thanks, Dad. I loved you for that.

"But it's important to dance well," my mother persisted. "Everyone remembers a good dancer."

"Everyone remembers a good sniper, too," I told her.

Occasionally circumstances beyond my control forced me onto the dance floor. At sixteen I was an usher at my brother's wedding. While the band played, I highlighted my role as "Bridal Party Geek" with a classic display of rhythm retardation. My attempts at dancing had the photographer laughing so hard that every picture taken of me that night captured what appeared to be a tuxedoed smudge.

Sometimes I found myself at parties where the living room furniture was suddenly cleared away and, to my horror, everyone started to dance. Somebody always pulled me into the whirlwind of thrashing bodies before I could make my escape.

When you dance, the steps should flow from you naturally. When I dance, the only thing flowing from me is perspiration. I look gangly and oafish. This image isn't limited to the dance floor.

I seldom notice the last step at the bottom of a staircase. I also add one at the top that isn't there. The way I usually meet new people is by walking into them. Walls seem to leap in front of me whenever my head is down. Ottomans scuttle into my path. Any piece of furniture with a pointed edge somehow seeks out my shins to say "howdy." My arms, legs, hands and feet often fail to unite toward a common goal.

Dancing should involve graceful, coordinated movements which are pleasing to watch, not the stiff and jerky flailing of body parts in random directions. Some people dance the way a greyhound runs. I dance like a rabid junkyard dog weaving its diseased way through the dump, shaking, growling, its teeth in a clenched, tortured grin. On the dance floor I should be shot, to put onlookers out of their misery.

Dancers don't understand non-dancers. They can't relate to us. We're spoken of in terms used to describe psychotic killers. Dancers shake their heads and say, "I don't understand—he seemed like a normal guy. I used to talk to him. He was always friendly…never caused any trouble in the neighborhood…kept to himself…minded his own business." They pause and shudder. "But when I saw him on the dance floor—well, it was shocking."

On the night of my high school prom, I stayed in my bedroom and watched a Laurel and Hardy film festival on television. "Somewhere tonight," I told myself, "a beautiful girl who hates to dance is at home alone, avoiding her senior prom. One day we will meet."

Eventually I did meet her. In fact, I met several beautiful, non-dancing girls, all of them married to guys who *loved* to dance. God, it seems, takes perverse pleasure in pairing dancers with people whose sense of rhythm is limited to drumming their fingers absently on the table while their partners gyrate on the dance floor with someone else.

Anyone for a Laurel and Hardy movie? I'll make the popcorn.

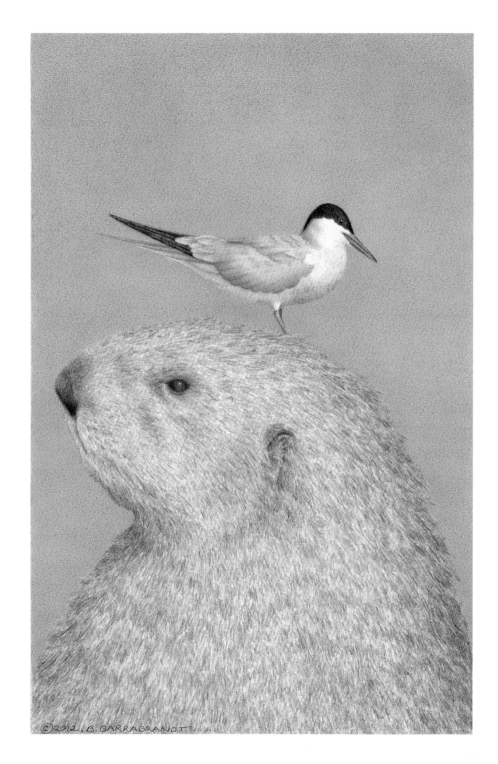

One Good Tern Deserves An Otter

Maneigh

©2012. B.GARRABRANDT

Pecking Order

Licensed Maseuss

Great Fish Stories

Moozart

After Dinner Drink

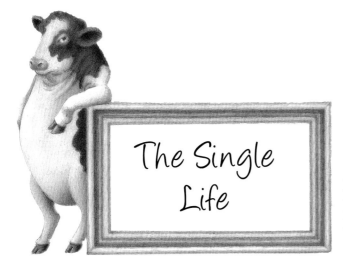

The Single Life

I've never had much luck with women. Even as a little kid, playing doctor with the girl next door, I chose Doctor of Philosophy—and she always fell asleep. (I wasn't a popular kid, period. All children have imaginary friends, and I was the imaginary friend for all the kids in my neighborhood.)

I didn't really date anyone until college. I'll never forget my first love. Communication with her was excellent. One day we were talking about our relationship, and I asked, "What do you really want out of it?" She said, "I really want out of it." I never understood why she broke up with me. I was an easy person to get along with. I'm sure my college roommates would agree—all 19 of them.

I always thought my college sweetheart and I would get back together after a few years, but I guess by then she had too much invested in therapy.

Later I dated a girl who told me I looked like Gary Cooper. When I tried to thank her, she pointed out that Cooper had been dead since 1961.

I met a girl in a bar once, and we started seeing a lot of each other. She said she wasn't interested in a man's looks. She wanted to know what was inside a person. It took me about a month to figure it out—she had an X-ray fetish.

Years ago, I answered one of those "personals" in the classified section of my local newspaper. It read, "Looking for someone to share romantic evenings by a fire." Turns out she was a pyromaniac. I spent a fortune on marshmallows.

One woman I dated inspired me to write a country music song. I titled it, ***She Told Me I Was Number One, But Treated Me Like Number Two.***

Well, the single life taught me one valuable lesson: Never date a woman who considers a billy club a fashion accessory.

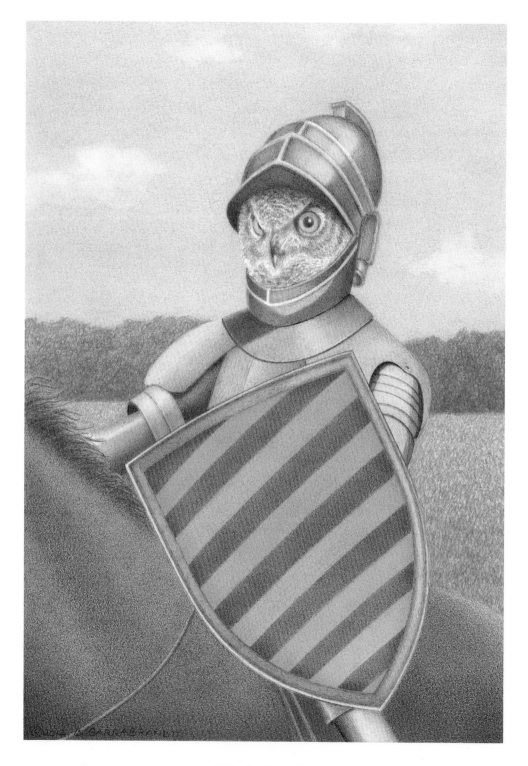

Knight Owl

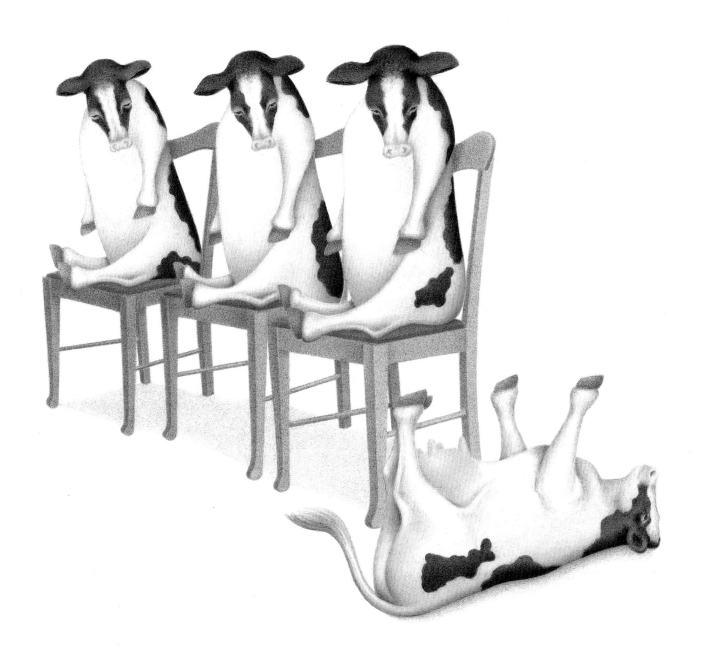

Moosical Chairs

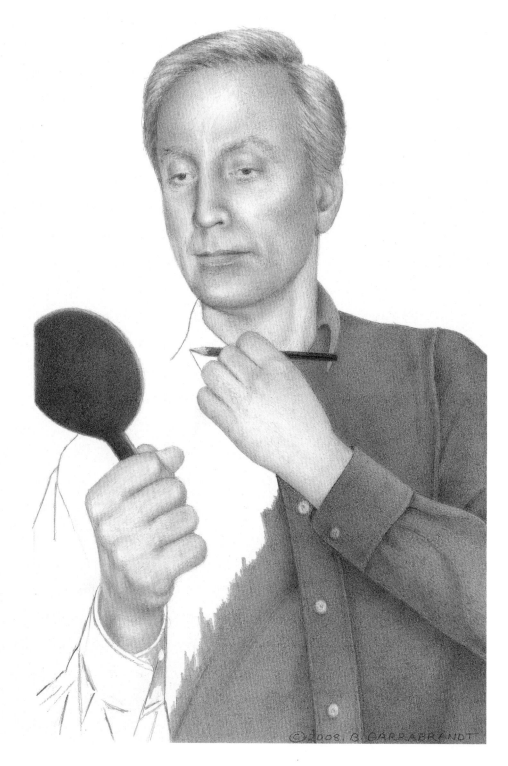

Self Portrait

Scrambled Eggs

Cownga Line

Ladies In Wading

Draught Horse

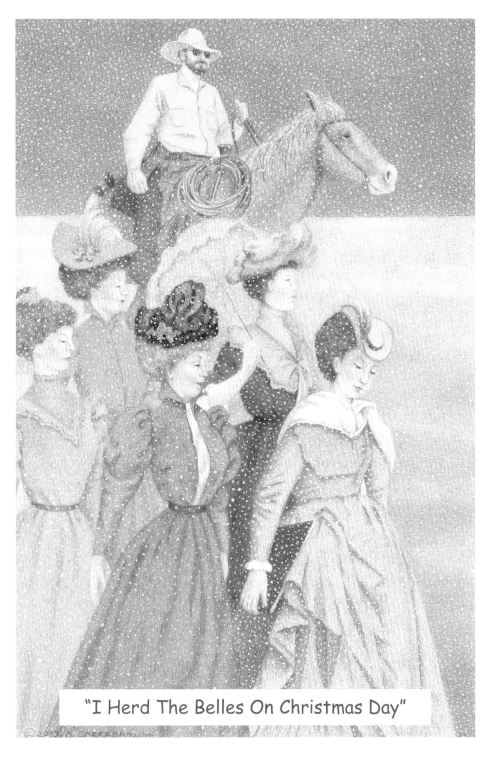

"I Herd The Belles On Christmas Day"

Failed Christmas Carols

Memories of a
Mathematical Misfit

I've often heard that a strong correlation exists between math and art. No one, even when speaking slowly, using only monosyllabic words, has been able to explain this to me in a way I can understand.

I am a mathematical misfit. When I dine with friends at restaurants, our sadistic waitress inevitably leaves the check next to *my* plate. The coffee cup I'm holding begins rattling against the saucer. I take my hand away.

"Figure out what we owe," one friend says to me.

"How much with the tip?" asks another.

Everyone at the table is looking at me. I stare at the bill, dumbly. Numbers blur and swirl before my eyes and *The Star Spangled Banner* starts to play inside my head. My mind has signed off for the night.

Finally someone snatches the check from my limp hands and quickly performs the necessary calculations as I sit there feeling dazed and stupid.

If you can't relate to the above scenario, you were probably one of those irritating kids in high school math class who completed every homework assignment, wrote neat, flawless equations on the blackboard, and always finished math tests twenty minutes before everyone else. I'll bet you sat wearing a smug look, deliberately covering your answers so that desperate classmates seated around you, craning their necks, couldn't see what you wrote.

I hate you.

I am writing for the millions of emotionally scarred men and women who suffered through years of mathematical hell in high school. Like me, you know the expression "math appreciation" is, without question, the most glaringly offensive oxymoron known to man.

I remember when mathematics turned sour for me. All through the elementary grades we learned benign arithmetic with its easy addition of apples and friendly multiplication of oranges. Then seventh grade arrived. The

behavior of people in word problems grew erratic and bizarre. They no longer gave each other apples or oranges in the spirit of goodwill. Now they were rowing boats in frantic competition. They jumped onto trains speeding away in opposite directions. They made endless comparisons of pocket change for no apparent reason. A darkness had descended upon the landscape, and it was called "algebra." This was the Monster of Math, an evil thing spewing endless streams of binomial and quadratic equations. Familiar numbers now became unrecognizable symbols and letters until everything looked coldly foreign.

An invisible sign was posted on the wall outside my algebra classroom: *Check Your Self-Esteem At The Door.*

Blindly we followed an arcane school regulation that all Algebra I classes be scheduled for the first period of the day. At 7:45 a.m., a boy's morale is at its lowest ebb—if it is anywhere at all.

From September to June the classroom atmosphere was always hot and stifling. The air was dense with talk of integers, polynomials, and other arithmetic atrocities. Harsh orange sunlight glared through cracks between the rows of window shades. Five minutes into the period I felt drugged, alpha waves flooding my brain with the message to *sleep now…go ahead and relax…that's right…no one is watching…just drift into dreamland and…*

Wham! My head crashed onto the desktop. I bolted upright, fully awake now and aware of several dozen faces looking at me.

The teacher, Mr. Snavely, stood at the blackboard, slowly tapping an eraser against the palm of his hand. "Am I keeping you awake?" he asked coolly.

"Evidently not," I said, rubbing my forehead.

His eyes narrowed. In fact, they seemed to disappear behind the thick lenses of his glasses. "See me after class," he said.

Mr. Snavely was five feet, four inches tall, the thinnest, palest human being I'd ever seen. He looked like a large, animated stick of clothed chalk. If he weighed a hundred pounds, his heavy dark-framed eyeglasses accounted for at least ten percent of that weight. The braces on his teeth were an unnecessary expense, because Mr. Snavely never smiled. Why should he? He was a math teacher.

The only time we were aware of his dental hardware was when he yawned. This stretched the tiny rubber bands hooked inside his mouth and sent them flying off the braces, out into the rows of students.

Then there was Mr. Snavely's hair. Nobody knew exactly what ritual he performed on it, but the class consensus was that it involved handfuls of wheel-bearing grease slathered through his black curls and massaged into the scalp.

The procedure must've made combing his hair difficult, because he never bothered to do it. The hair on his head lay in random clumps, like the ingredients in a freshly tossed salad.

It surprised no one that Mr. Snavely was a bachelor. His love, the object of his desire, his purpose for living was, and would always be, algebra.

The period bell rang. Everyone filed out of the room while I stayed behind to endure The Snavely Lecture, delivered to me at least once weekly. Always it was the same warning:

"You'd better pay attention in class and start applying yourself, young man, or you'll never amount to anything in life. No college wants an algebra failure."

I left his after-class lecture determined to pay attention and apply myself. Next morning I returned to my seat a new man. "Today will be different," I told myself. "I will listen. I will master algebra."

As class began, Mr. Snavely stood before us to give a spontaneous mental math problem. The correct answer would win extra-credit points for a quick-thinking student.

"Two times fourteen, minus seven, divided by three, plus forty-three," he rattled off briskly, "divided by two, plus seventy-five, minus ninety-nine, equals how much?"

Immediately hands went up all around me, waving madly in the air to catch Mr. Snavely's attention. My hands became a chin rest. I sat there quietly tuning out the classroom, allowing my mind to drift into heroic, manly daydreams. Moments later I was sheriff Gary Cooper, standing alone on a dusty western street, ready to face a half dozen outlaws, knowing my life would probably end in a shootout at high noon. The town was silent. The streets, empty. I'd brought law and order to this town, but the people I thought were my friends had deserted me. Even my Quaker wife was leaving on the next train. The air felt hot and stuffy. No breeze stirred. The sun burned the back of my neck as I recalled my wife's parting words:

"Killing for any reason is wrong. What does it matter who is right or wrong? And what does 'x' equal?"

Huh? I glanced up from my reverie. Mr. Snavely was looking in my direction, pointing to an equation on the blackboard.

"What does 'x' equal?" he repeated sternly.

The blackboard was littered with all sorts of mysterious equations. "When did *this* happen?" I wondered.

Holding his chalk against an "x" on the blackboard, Mr. Snavely stared at me, waiting for my answer.

He kept waiting.

I gazed stupidly at the equation, frowned, and said nothing. I prayed for a fire drill to come at that moment, or a civil defense drill. A surprise nuclear attack would be preferable to sitting there with all those eyes on me.

More excruciating seconds passed. Finally Mr. Snavely turned to call on one of two dozen eager, hand-waving students about to explode with the answer. I, Sheriff of Stupidity, was left behind in the mathematical dust by an algebraic stagecoach racing away without me.

Not all mornings were spent daydreaming or fighting the urge to doze. Some days involved actual sleep. Often it was easier just to let the alpha waves have their way with me. I developed a variety of successful methods for sleeping undetected through math period. As long as I refrained from snoring, the following techniques usually worked:

With elbows on the desk, I'd place both hands against my forehead directly above the eyes, as if to shade them. With my head tilted downward, this created a look of studious concentration, so long as I didn't drool.

Seeking out one of the larger class members, I'd sit directly behind this person, slouching down far enough in my seat so that the teacher couldn't see me.

Some mornings I'd sit with arms folded, close my eyes and use both thumb and index finger to pinch the bridge of my nose. In this pose I appeared to be either absorbed in some weighty point the teacher had just made, or else suffering migraine pains in stoic silence. Either way, the teacher might sense in me some profound, personal struggle and leave me alone.

I used every means possible to get myself through each day's math class. To me, algebra was like a daily warm-up act for Hell.

The inside back cover of my algebra textbook listed names of students who'd used the book in previous years. I'd glance down the long row of names, ending with mine, and wonder if I was the first to be driven mad by this terrible text.

Each chapter ended with a page full of "Exercises." I ignored these, performing instead an exercise of my own, which combined hyperventilation with a rapid heartbeat.

Being called to the front of the room with other classmates to scrawl algebraic homework problems onto the blackboard was akin to having the teacher say, "Would you like a blindfold? A last cigarette? Have you any final words?"

I was in awe of humanoid students who could walk coolly to the blackboard with me and write legible equations.

Their numbers never slanted. Their answers were invariably correct. These kids always sat down before I did, leaving me up there to plod through a math problem that, for me, would forever remain a problem.

Seasons changed before I returned to my seat, at which point the teacher performed major surgery on my work. The patient always died in the process. Step by step, Mr. Snavely erased everything I'd written except my name. I sat at my desk feeling like the character Lenny in *Of Mice And Men*, who had inexplicably stumbled out of the Steinbeck novel and into a high school math class.

"And—uh—I'll tend the rabbits, teacher," I imagined myself saying.

On Parent-Teacher Nights, Mr. Snavely would corner my parents to register the complaint, "Your son does not apply himself." This wasn't true. The problem should've been worded differently:

"Your son *cannot* apply himself. He is physically and mentally incapable of dealing with algebra on any level. The mere suggestion that he apply himself is enough to start him whining and staring blankly into the distance. At such times I take his pencil away, afraid that he'll hurt himself."

The logical, left side of my brain was empty enough to plant daisies there, but chunks of algebraic information must've slipped into my skull by way of the subconscious, because somehow I managed to pass the course. Perhaps Mr. Snavely took pity on the mathematically brain-dead.

The guidance counselor called a meeting with my parents at the end of that school year.

"We have a special class for students who need to enhance their basic math skills," the counselor said. "We think your son should enroll for September." (Translation: "We can place your son in a remedial math group with students whose average I.Q. is one point above that of road tar.")

Remedial geometry class was full of kids who longed for their sixteenth birthday, when they could quit school and spend *all* their time loitering and stealing cars. We learned nothing. The teacher's vocabulary was limited to several short phrases repeated constantly throughout the school year:

"Sit down now!"

"Stop talking!"

"Put that knife away!"

I received an "A" in geometry, even though the knowledge I retained from that course consisted only of a few facts about Pythagoras, including how to spell his name. Pythagoras was an ancient Greek mathematician. (All Greek

mathematicians were ancient, math having withered their bodies, sapping them of youth and energy.) Pythagoras spent vast amounts of time fretting over "rational" and "irrational" numbers. No one knew what he was talking about. People did their best to avoid him on the street where he roamed day and night, calculating to himself and walking into parking meters.

"The total number of rational numbers is without end," he told passersby.

"That's Greek to me," they said to him, quickly crossing to the other side of the street.

"Do you understand the concept of infinity?" he'd call out, but by then they were running and could no longer hear him.

I didn't need to understand Pythagoras to comprehend the concept of infinity. Infinity was that interminable period of time during which I was required to endure math class.

Earning a respectable grade in geometry landed me in an accelerated Algebra II course the following year. It was taught by Miss Young, a recent college graduate with a minor in Psychology. Miss Young was eager to experiment with her newly acquired understanding of human behavior. I became her laboratory rat.

"Your problem is not with the math itself," she told me one day after class, "but with how you approach the text."

"I want to approach it with gasoline and a lighted match," I replied.

"If you find a math chapter too difficult, try going back to where you last felt comfortable," she suggested.

"How about the womb?" I asked.

Miss Young said I could easily overcome negative feelings about math through the practice of affirmations, a daily repetition of positive suggestions.

So I tried it. In algebra class the next day, I sat down and wrote across the top of a notebook page, "I Can Concentrate And Learn Math." For emphasis I underlined each word twice. Then I slowly drew a bold box around the affirmation. As Miss Young droned on at the blackboard, I carefully colored in each "o," "e," and "a" in the affirmation. Next came a fancy scalloped border around the box. I was about to start shading in the entire area when I heard my name called.

"Can you tell us what 'x' equals?" Miss Young asked me.

Strange equations again filled the blackboard, only this time my mind leapt into action, telling my eyes to look

down and study the hairs on the back of my hand; which I did. The room was still. I wanted desperately to believe that if I continued looking at my hand long enough, it and the rest of my body would somehow dematerialize from the room. Finally an exasperated Miss Young called upon someone else for the answer.

"Please see me after class," she told me.

I sat at my desk and fantasized the worst possible scenario:

"Take this note home with you," Miss Young would say, handing me a folded slip of paper. The note instructed my mother to stitch a scarlet "A" onto all my shirts, symbolizing the crimes I was committing against algebra and God. I would be exposed to constant ridicule from students fluent in factoring algebraic equations. People who knew their polynomials would taunt and jeer me on the street. Late one night an angry mob of mathematicians waving lighted torches would descend upon my house to drag me from my bed and pummel me to death with exponents, square roots, and radicals.

But Miss Young didn't reach for a pen and paper when the period bell rang. Instead she sat at her desk and calmly suggested that we begin after-school tutoring sessions, three days a week. Her tone was optimistic.

"The amount of fun you can have with algebra will surprise you," she said.

"It certainly will," I said.

For several weeks I reported to her class dutifully for after-school instruction. Miss Young was a patient, caring woman. But her dedication as a teacher was no match for my mental impairment. She tried positive reinforcement, biofeedback, and other psychological approaches to make me mathematically functional. Nothing worked.

I continued to receive failing grades on math exams. Test days always held a special humiliation for me. Algebra II was the class period just before lunch, and my stomach gurgled.

Miss Young would hand out the test, and I'd put my nose to the mimeographed paper, breathing deeply, hoping the fumes I was inhaling would rush to my brain and cause unconsciousness, thus making test-taking impossible. This never happened.

The room grew silent except for the sound of pencils scribbling against paper, and an impromptu speech— delivered by my stomach. It started with a few low grumbles, or introductory remarks:

"Grraauurr!" it announced to the class. "Grrauurrgh!"

I coughed and dropped a book to the floor, hoping to drown out the noise. My stomach then launched into full-

blown oratory:

"Brrraawwwrrgrr—gauwwrrouk!"

The kids seated near me were all snickering now.

"Gauwwrrrauwwwgrrrr!"

The sounds emanating from inside me were like the satanic moans heard from little Regan in *The Exorcist*, only mine were louder and less friendly. I was too embarrassed to focus attention on algebraic problems, and so I failed.

One afternoon I walked into my tutoring session to find Miss Young seated at her desk, leaning forward on her elbows. She looked defeated. Her laboratory rat had died and she knew it.

"Look—you've made an effort," she said quietly. "I can see that. But there's no point in continuing these after-school sessions. The class will be given three more tests and four quizzes this year." She paused now to look at me. She sighed. "Pass just one quiz and I'll pass you for the course."

On test days, I gorged my stomach with cookies to keep it from growling and managed to squeak by with a "D" on the very last quiz of the year. With tears in my eyes I hugged Miss Young, staggered out of her classroom and into the sunlight of a world where at last I'd be forever free from the agonies of algebra.

Recently, I learned how to handle eating in restaurants with friends, sipping coffee after dinner, waiting, without dread, for the waitress to bring the check and place it in front of me—which she always does.

"What do I owe?" one friend asks me.

"How much with the tip?" inquires another.

Casually, confidently, I glance at the check and turn to the inquisitive faces of my dinner companions.

"You take care of the tip," I tell them. "Dinner is on me."

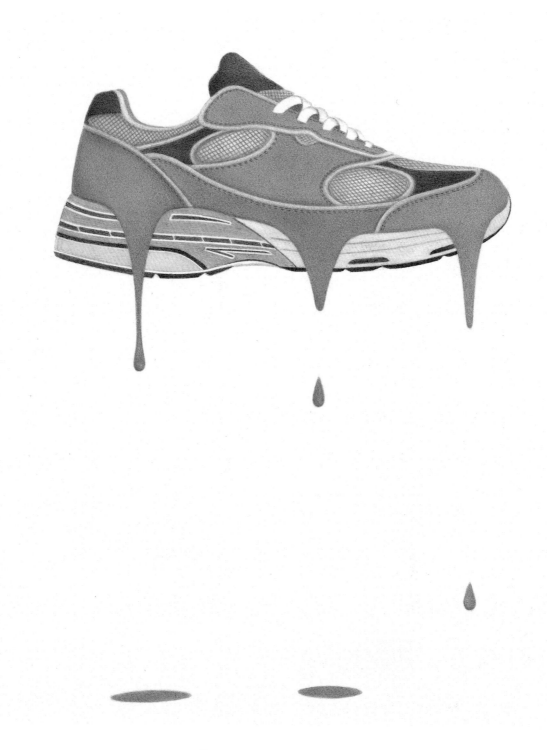

Running Shoe

Unwise Vacation Destinations

Marsoupials

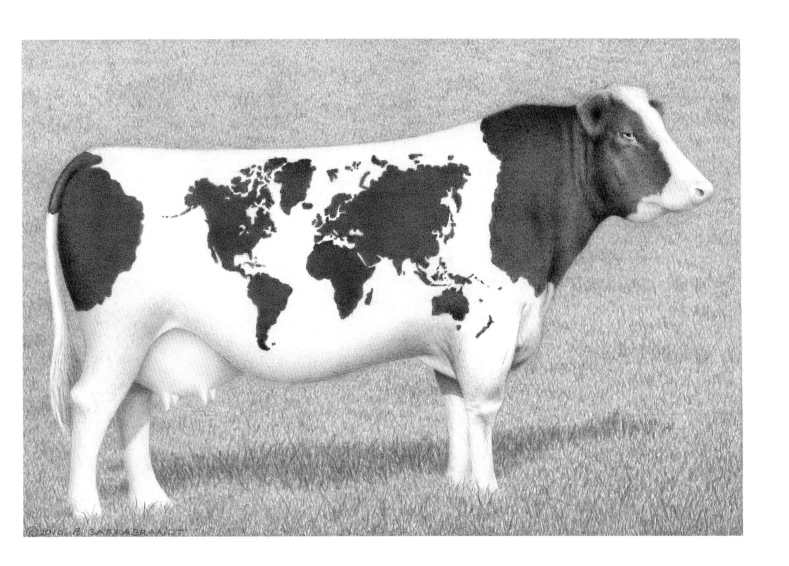

Cowtographer

Flower Bed

Facing The Music

Lassietude

Fatal Attraction

"Here's looking at you, kid."

Still Life With Fruit

The Last Of The Moohicans

Summer Camp

When I turned twelve, my parents enrolled me in a summer day camp. The brochure announced the opening of "Happy Brook, a new camp for boys, promoting physical fitness and social interaction through a variety of fun activities." One of these activities was **Arts and Crafts**.

"Wow!" I thought. "I can learn to be an artist. I'll spend the summer making things!"

The camp director came to our house one evening to explain to my parents why Happy Brook was the best place for me to spend the summer. Calvin Carter was in his early thirties, tall, thin, dressed in a dark blue suit. He asked us to call him "Coach Cal," but he looked more like an insurance salesman than he did a camp director.

Calvin had managed the pro shop at Happy Brook Country Club for six years, saving enough money to purchase an adjacent parcel of land from the golf course owner. He'd bought the property to fulfill a long-festering dream to run a summer day camp.

"Happy Brook welcomes local boys, ages eight to fourteen," he said. "Our goal is to provide unique recreational activities for the development of the camper's mind and body."

The camper's goal, I would soon find out, was to survive the summer.

On my first day at Happy Brook, I learned there was no brook--and no happiness. Our morning assembly provided a patriotic start to the day camp experience. The garbled recording of a bugle blared reveille over the public address system, summoning all campers to gather around the flagpole in the center of camp. Here we were separated into clots of six, called "Wolf Packs," each pack being assigned its own counselor.

Counselors were college students. Many of them came to work with hangovers. All of them viewed campers as an inconvenience to be endured while getting a tan.

We stood at attention that first morning and heard a scratchy record of Kate Smith straining to sing *God Bless America* over loud crackling and popping noises and the shriek of feedback from the public address speakers.

Then Coach Cal appeared, carrying a clipboard. He was dressed in khaki camp shorts and tee shirt, looking less impressive than he had during his visit to our house. His bony frame and concave chest were a marvel to us campers. We wondered how he'd lived so long without a rib cage. His ankles were too thin to hold up his socks, so he used a rubber band around the middle of each calf. We nicknamed him "Coach Cadaver." He looked like an escapee from embalming school. When he spoke, his Adam's apple bobbed up and down like the float on a fishing line.

"Something has gone wrong with our underground pipes," he announced that first morning, "and we can't use the swimming pools. We hope to have the problem corrected in a couple of days." The camp had two large pools. The water in both had turned a suspicious-looking brown. No explanation was given, but the smell of raw sewage told the story.

"Oh well," I thought, "with no swimming lessons I can spend more time learning arts and crafts." I was delusional.

The three principal camp activities were sunburning, sweating, and fainting. None of these was mentioned in the camp brochure, probably due to space considerations. That summer saw a heat wave with record-breaking temperatures. Happy Brook, with its two in-ground, chlorine-treated cesspools and total absence of trees, wasn't equipped to handle the heat.

Most camp activities, including arts and crafts, were held inside one of ten plastic tents, squatting in a long row along the end of camp. In reality these were baking ovens. Few campers could stay in one longer than five minutes. Boys were regularly carried out on stretchers after swooning from the heat.

An infirmary is usually not the most popular spot in camp, but at Happy Brook it became something of a shrine. Campers pilgrimaged there daily in search of heat relief.

Our camp nurse was Coach Cadaver's mother. The woman we called "Aunt Rose" was thin like her son, but tough and leathery. Aunt Rose was a chain smoker. She spent most of her time in the small, air-conditioned infirmary, playing poker with the maintenance men and drinking beer. We kids were afraid of her. She had hard grey eyes like marbles. Her yeasty breath was a pungent bouquet of ashtrays and Rheingold.

Between poker hands, Aunt Rose dispensed hundreds of ice cubes wrapped in napkins, and draped wet paper towels across dozens of campers' foreheads. She sent every kid outside again with a slap on the rear and the words, "You'd better toughen up a little."

Happy Brook cooked what the camp brochure described as "a nutritious hot lunch," served from the counter of a small, outdoor lunch stand in the center of camp. Hot dogs, large pale pretzels, and cold soft drinks were the daily menu. This was food to build our young bodies, to prepare us for adulthood with its promise of diabetes,

hypertension, and hardening of the arteries.

An hour of "free swim" was scheduled for each afternoon. This gave us campers a chance to hold our noses and mill around the foul pools for an hour. Our lifeguard spent this time in the infirmary, playing poker with Aunt Rose.

The same plumbing problem polluting the pool water also rendered our restrooms unusable. Portable johns dotted the campsite. These taught campers a valuable lesson: Don't dawdle inside. You had to get the job done quickly before the sun welded the plastic door closed, creating a sauna/mausoleum, "sanitized for your protection." The heat in these johns could bake a human being into oblivion, but the high temperature seemed to enhance the growth of any spider taking up residence there. They swelled to the size of party favors and challenged the smaller campers for a seat.

As the afternoon sun seared its way across the summer sky, campers with stomachs bloated by too many sodas sloshed from one patch of shade to the next, trying to avoid heatstroke. Some lay sprawled on the ground in the temporary shade of a camp bus. We looked like models for a new Norman Rockwell painting, *Death At Day Camp*. When Happy Brook's brochure suggested that name tags be sewn into all clothing, no one realized it was for identification purposes when parents came to claim the bodies.

By day four at Happy Brook, Coach Cadaver was keeping out of sight. He was in way over his head, and knew it. That afternoon campers exhausted the supply of ice cubes. Coach Cadaver had to leave camp to buy more. He sneaked into his air-conditioned car and tried to drive away quietly. But we campers spotted him and swarmed his car, pounding it with sweaty little hands and pressing our sunburned faces against the cool, closed windows, shouting at Coach Cadaver to open the doors. That rattled him, but he just crept along the driveway in reverse until he could make his escape, like a hunted animal darting off down the highway and out of our reach.

That was the same day we lost Donald, our arts and crafts instructor. Campers had frustrated him for the past three days by putting Popsicle sticks up their noses, gluing ceramic tiles onto each other's camp shorts, and engaging in other antisocial behaviors.

"Every camp has its flowers and weeds," Donald said that fateful morning. "We all appreciate a flower, but no one likes a weed."

We campers looked at each other, puzzled, thinking we'd wandered into a botany lesson instead of the arts and crafts tent.

"From now on I expect you all to be good flowers." Donald's hands fluttered in the air. "Weeds will be uprooted and thrown out of arts and crafts."

Poor Donald faced a tent full of weeds. The few campers who may have been borderline flowers looked at Donald's flitting body movements, heard his strange way of speaking, and decided at once to join the weed crop.

A sheet of art paper and a box of crayons were given to each camper. "Today I want you to draw your favorite tree," said Donald. "But I don't want to see this." He drew a large circle in the center of his paper and connected a vertical line underneath for the trunk. "This is a lollipop tree. I *don't* want to see lollipop trees."

After widespread whispering and snickering among the campers, everyone went to work with crayons and paper. A few minutes later Donald asked us to hold up our drawings. We did. What he saw were dozens of trees covered in lollipops. He breezed out of the tent in a snit. That was the last we saw of him.

Late that night, I lay awake remembering the camp director's visit to our house. I replayed his little speech now in my head, supplying a much needed Sales Pitch Translation:

"Our camp provides a safe environment for boys. *{Boys can't get into trouble when they're on the ground from heat prostration.}* Campers will enjoy a feeling of belonging—a real camaraderie. *{Misery loves company.}* Their confidence will grow through meeting challenges of the great outdoors. *{Nothing builds character like defying Death in the noonday sun.}* Campers will develop a strong awareness of self. *{With sunburn covering eighty percent of their bodies, campers will be extremely aware of self.}* I am proud of our unique institution. *{I belong in an institution.}* I will do my best to make camp a memorable experience. *{The emotional scars may last a lifetime.}*

The next morning, my mother woke me an hour later than usual. "You don't have to go to camp today," she said quietly.

I sat up in bed and blinked at her. "Why not?"

"There *is* no camp anymore," she said. "Coach Cal was arrested last night. He torched the camp tents. The radio said he had some kind of breakdown. His mother was arrested for illegal gambling and assaulting an officer."

My emancipation! For the rest of that summer I kept to my bedroom, hunched over an art pad, determined to teach myself how to draw. My mother would shout from downstairs, "It's a beautiful day outside. You should get some sun."

No way, thank you. Even today, four decades later, summer finds me indoors, sitting so close to the air conditioner, I have grille marks on my forehead.

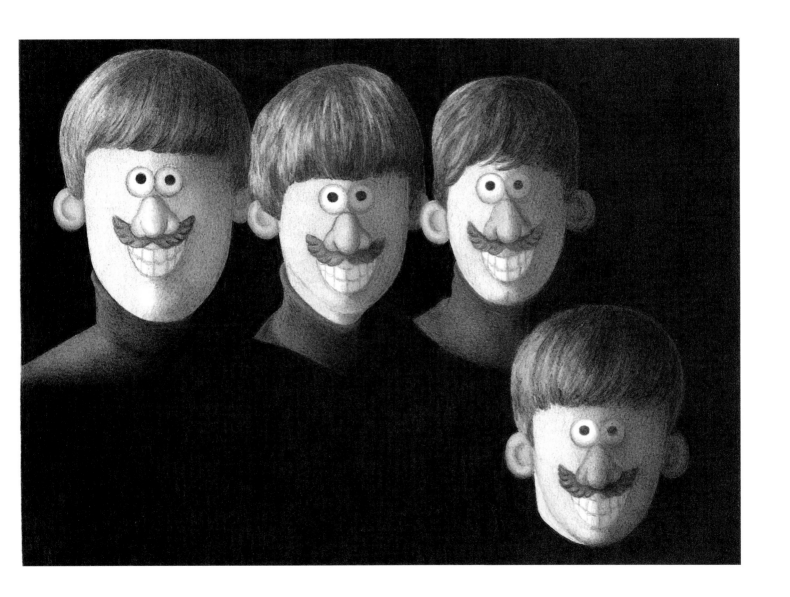

Potato Beatles

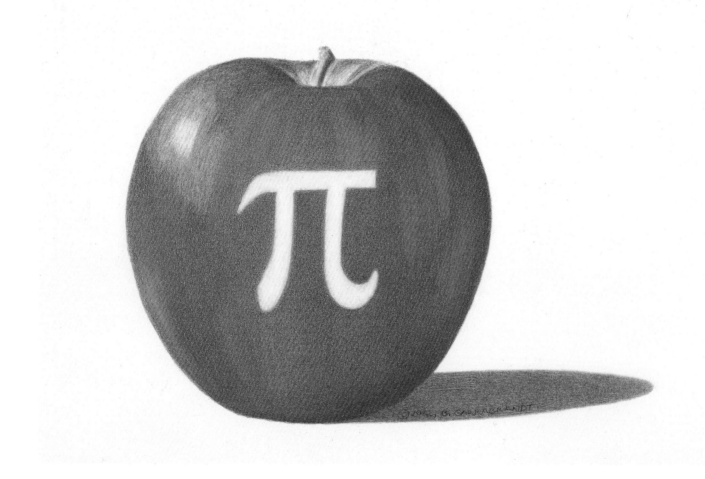

Apple Pi

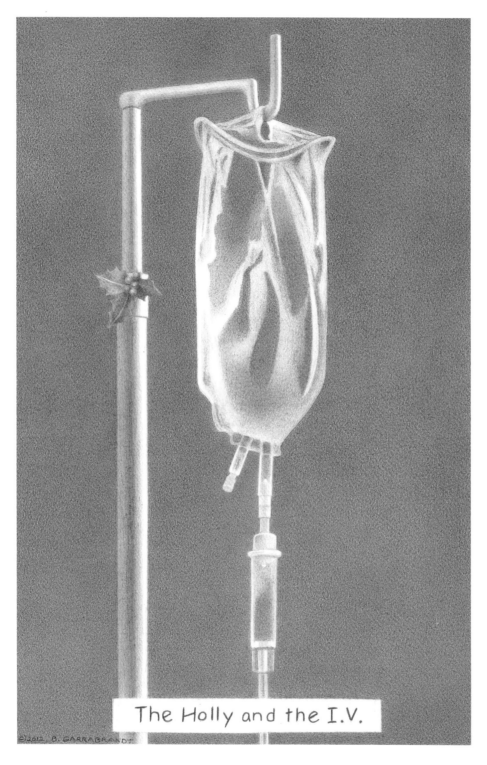

The Holly and the I.V.

©2012 B. GARRABRANDT

Failed Christmas Carols

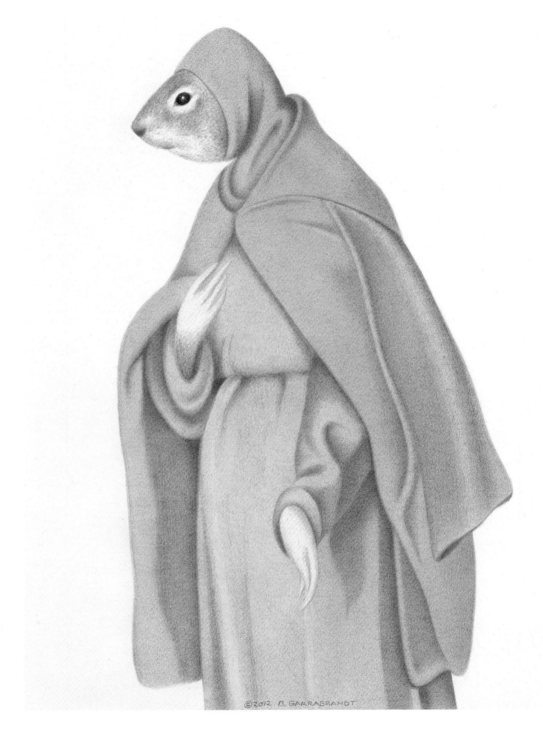

Chipmonk

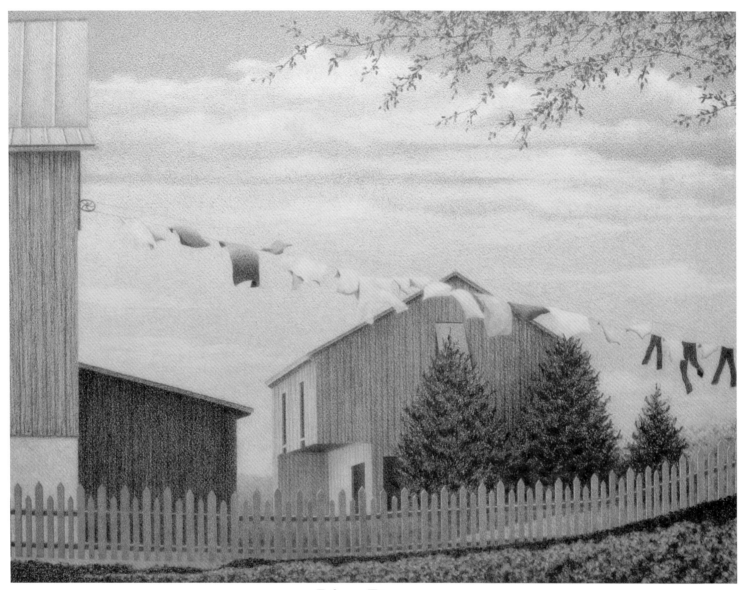

Line Dance

Laundry lines like the one above are a common sight in Pennsylvania Dutch Country—every day but Sunday. Trivia question: Why do clothes dried outside on a laundry line have a sweet smell to them? Answer: Ozone. It's nature's purifier.

15 Minute Parking Only

Cowlumbus

In A Bad Neighborhood

From The Mail Bag

Following the publication of my first coffee table book, *Cattle Drive*, I received countless letters from thoughtful readers. Many of you wrote to ask me questions. It was impossible to answer everyone individually, and I do apologize for that. Please keep in mind my busy schedule, frequent naps, and short attention span.

My secretary has selected some of your more legible, coherent letters, and I'd like to address a few of these and provide somewhat coherent answers.

Your comments about marriage were so negative and cynical. Don't you believe in abiding love?
Irma Farquar, Lasso, OK

Yes, Irma, I do. Abiding love is wonderful—while it lasts.

You mentioned God's name several times in your last book. Don't you think evolution makes God unnecessary? Or, are you one of those creationists? If you are, you may as well believe the Earth is flat.
Ed Fenster, Frostbite, ND

The Earth *is* flat, Ed. It's the curvature of your eyeball that makes it appear round.

Should chicken be eaten with the fingers?
Susan Weemer, Agita, AZ

Chicken can be eaten with the fingers, Susan—but the fingers are often hard to digest.

Did your parents encourage you to follow your dreams?
Gerald Gorbel, Flinton, DE

My parents always told me to shoot for the stars, so for a while I was a sniper in Hollywood. Mom and Dad made a point of saying, "Bruce, never be embarrassed or ashamed. Let us be embarrassed and ashamed for you." My parents did encourage me to pursue my passions, and they fostered self-reliance in me. When I was younger and still living at home, they took me aside one night and said that it would be good for me to get my own apartment and learn to fend for myself. I was six at the time.

Being an English major, can you tell me—what is a dipthong?
Edward Orange, Codey, NJ

That's an easy one, Edward. A dipthong is skimpy underwear in the salsa.

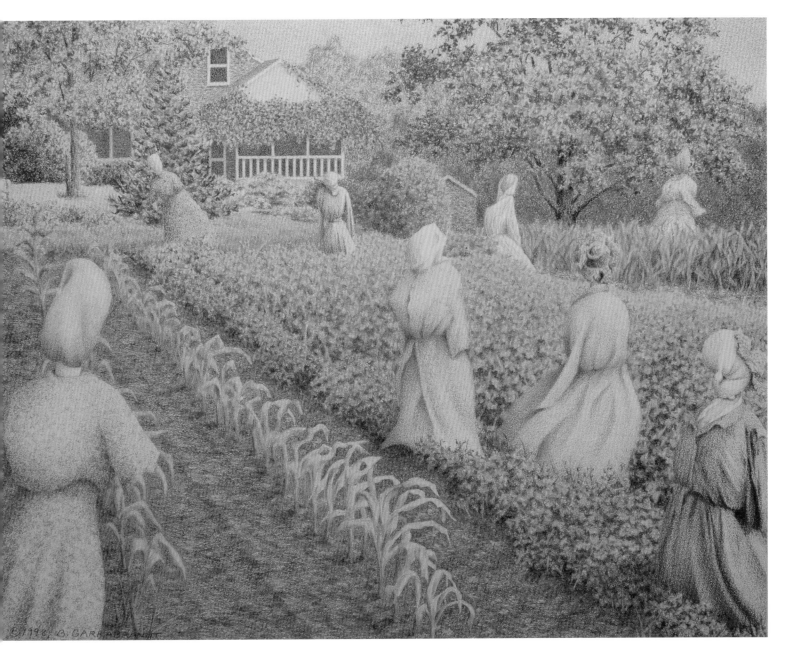

Ladies' Garden Club

Pictured here are Mennonite scarecrows. This scene features the Huber sisters' garden in Terre Hill, PA. The scarecrows are dressed in the Mennonite sisters' old clothes, which has resulted in more than one neighbor trying to carry on a conversation with a scarecrow. (In winter, these ladies are stored in the outhouse.)

How We Get Irish Cream

Great Fish Stories

Bad Suspense Films

"I'LL BE HOME FOR CHRISTMAS"

Failed Christmas Carols

Nixon Opens The Door To China

Dysfunctional Tenderfoot

Seventeen years ago my wife, Jan, and I moved into Pennsylvania Dutch Country. Her dream was to buy an old home and open a bed-and-breakfast. My dream was to enjoy a slower pace of life. Both dreams have become reality, but an older home (ours was built in 1848) requires a lot of routine maintenance.

My practical skills are limited. If the job can't be scraped, painted, or caulked, you don't want me anywhere near it. I'll just draw you a picture of the problem until qualified help arrives.

Silicone caulk, I've discovered, is a miracle substance. At our house it's been used on everything but the electrical outlets. Watching me work with a caulking gun, you might easily mistake me for Bob Vila—except that I sport a lot more adhesive bandages than Bob does.

General ineptitude and clumsiness have plagued me since childhood. They came into full bloom when I joined the Boy Scouts at eleven. (I wanted to quit by eleven forty-five.) My first look at the Scout handbook convinced me that I'd never measure up. It set impossible standards. The wholesome faces of Scouts beamed, without pimples, from its illustrated pages. These were clean, handsome young men. They would never need an orthodontist or acne medications. Their Scout uniforms were form-fitting and did not wrinkle.

"The hope of the free world," said the handbook, "rests upon the shoulders of young Scouts growing into responsible American citizens." This was not good news. I spent most of my waking hours stumbling into furniture and trying to keep a cowlick down. Now the entire free world was expecting me to save it.

Then there was the Scout slogan, "Do A Good Turn Daily." I tried my best with that one. Our town creaked with little old ladies crossing streets. I chose to help them. But I had poor peripheral vision. Word spread quickly among the local elderly that crossing streets with me was dangerous. Old ladies saw me coming and darted out into the busy streets, dodging and weaving through traffic just to avoid me.

I acknowledged my visual shortcomings. Thereafter, my Daily Good Turn was to leave old ladies alone to live out their natural lifespans in peace.

My only somewhat resourceful act as a Scout was to sew a pair of Indian moccasins, but I made a poor job of that, too. Anyone trying to know me by walking a mile in my moccasins would have been crippled for life.

Despite nagging feelings of inadequacy, I longed for the romance and excitement of Scouting. A Scout learned to be an outdoorsman and wield an ax, like great American pioneers Davy Crockett and Lizzie Borden. A Scout carried an all-purpose pocketknife containing several blades, a bottle opener, and other attachments, none of which I used until college, when the bottle opener came in handy.

Eager to earn my first Scout rank of "Tenderfoot," I set about learning to tie knots. A Tenderfoot needs this valuable skill. In any crisis, making knots calms your nerves by distracting you from the problem at hand. I had a lot of trouble with knots, so my scoutmaster offered to help.

"The best knot to use when putting up your tent," he began, "is the taut-line hitch." He picked up one end of a length of rope and looped it around a chair leg, making one or two other movements I could not follow, then pulled the rope tautly to create an odd-looking knot.

"Do you see?" he said.

"No," I said.

So he showed me again, this time very slowly, the way one would explain something to a heavily sedated trauma victim. He turned to me after making the knot a second time.

"Are you catching on?" he asked.

"Not really," I answered. It was hard to concentrate because my uniform was itching me. My mother had started using a new detergent containing "stain eaters," shown in television commercials as little, round, animated characters gobbling up dirt and grime from clothes. Evidently, the stain eaters were still hungry and decided to turn on me. I stood there battling an impulse to scratch everywhere the uniform touched my skin.

"Try to pay attention," the scoutmaster said, his voice a bit strained. "I want you to think of the end of this rope as a rabbit. Okay?"

"Okay," I said, clawing at my shirtsleeve.

"The rabbit comes out of his hole, runs around the standing part of the rope twice, and then through this loop." He paused now and studied my face intently, looking for some sign of brain activity.

"Do you follow this so far?" he asked.

I nodded, but was only half-listening as I squirmed inside my uniform. I wondered how the scoutmaster would react to my suddenly writhing on the floor.

"Then the rabbit makes one more loop around and we pull him tautly like this," said the scoutmaster. He untied the rope now and handed it to me. "You try it," he suggested.

Well, I got the rabbit out of his hole all right, but after the first loop around he fell to the floor and was never quite the same. I must have stunned him, because he couldn't make the right kinds of loops after that. The rabbit got twisted and snarled in the rope and then fell to the floor again.

The scoutmaster, until then a non-drinking man, stood up wearily.

"You practice at home," he sighed, "and we'll try it again next week."

Eventually, with the help of diagrams, countless scoutmaster demonstrations, and my mother switching detergents, I learned to tie knots well enough to become a respectable Tenderfoot. I would never make it to Second Class.

Most of the tests to become a Second Class Scout involved hiking. Hiking is in a Scout's blood. So when our troop took off for a weekend of hiking and camping, I was itching to go, thanks to a few vestigial stain eaters.

In the woods I learned to track an animal's footprints, see where they led, and what the animal had done there. When I found what the animal had done, I learned to scrape it off my shoe with a stick.

On that first weekend in the outdoors, I brought along a map from the U.S. Geological Survey. It was a topographical map, from the Greek *topos*, meaning "place," and *graphein*, meaning "how the hell do you read this thing?"

Another important piece of hiking equipment I brought was a compass. Actually, "pieces of a compass" is the way I'd describe mine, having inadvertently sat on it while resting on our first morning hike. I discovered it was broken only after I'd been left in the woods to find my way back to camp, using just the compass, map, and my cunning Scout instincts. This was an important test to pass on the path to the coveted Second Class badge.

I was alone and surrounded by forest. The scoutmaster expected me to follow a trail of broken twigs, footprints, and trampled underbrush that would lead back to the troop campsite. I whipped out my compass with its needle flattened and useless. I scanned the ground, found footprint tracks, and started to follow them. Soon I began to see broken twigs and branches. Only another hour passed before I discovered that the branches were being broken by *me* as I walked in a large circle, tracking my own footprints and trying to read the damned map.

I did not need trampled underbrush to guide me. I needed fluorescent orange traffic cones strategically placed along the route back to camp.

By now the sun was beginning to disappear behind the trees. I drew upon all my knowledge, experience, and abilities as a rugged, independent Scout, taking the only action any sensible pioneer would in this situation.

"Help!" I yelled, "Get me out of here! Hello, anybody? I'm lost!"

The scoutmaster, weary after his long search through the woods for me, removed a large flask from his knapsack as we walked in darkness together toward the campsite.

"Maybe we should put your solo hike on hold awhile," he said, taking several gulps from the flask. Hiking seemed to make him thirsty.

I won't bother to describe for you the rainstorm that managed to loosen my "rabbit-comes-out-of-his-hole" knots and blow down our tent later that night, or the poison ivy I developed the next day.

Upon returning home, I retired my Scout uniform, cleaned and pressed, with moth balls in the attic. Since that day the only good knots I make are those tied unintentionally with my shoelaces. And I still have no sense of direction. I've been known to get lost going from the house to the garage—and they're attached.

Weathered Faces

Madison Works On His Constitution

"Watson, come here—I need you."

Alexander Graham Bell Comes Out Of The Closet

Trained Seal

Mr. Potato Head Gets A Facelift

Guaca Mole

Down In Front

Adolph and Mao in Hell...

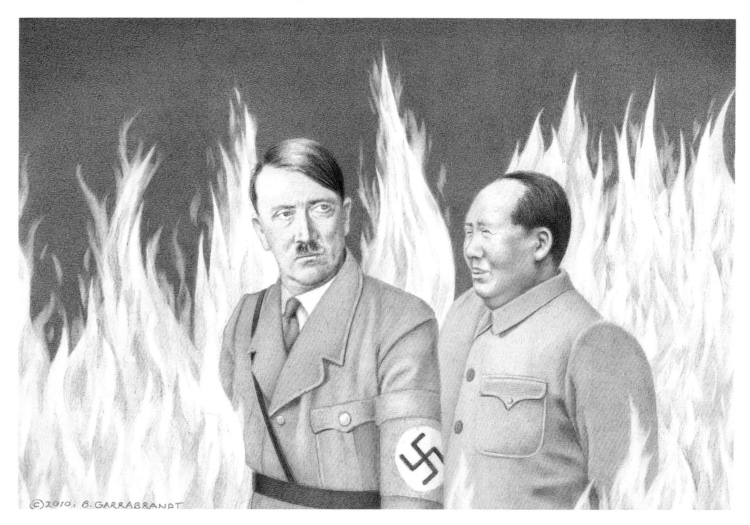

"Well--at least there's no humidity."

Oh Glorious Summer

A brief glance through any history book will show you that human beings are capable of great cruelty. They murder, they persecute, and they tell people the endings to movies they haven't seen. But man is also capable of great good. After all, he did create air conditioning.

Oh glorious summer, when Mother Nature lovingly combines heat and humidity to decrease the surplus population.

How anyone can prefer summer to winter is beyond me. Winter has so many advantages: the beauty of a snowfall, soft flannel shirts, romantic evenings by a cozy fire. You don't need to mow the lawn or pull any weeds. There's no perspiring. No climbing ladders to scrape, paint, or caulk anything. No battling with moles, voles, and grubs. And *all* the bugs are dead.

While it does have a couple of things going for it, summer is too high a price to pay for tomatoes and sweet corn.

I find the only way to handle the high heat and humidity of July and August is to sit very still, and pass out. A woman once said to me, "Summer is okay if you have access to a pool." No, lady—summer is okay if you have access to Alaska.

A friend of mine lives in Phoenix, where it's not uncommon for summer temperatures to reach 115 degrees. "But it's a dry heat," he tells me. Yeah, right. Did you ever make a pizza, and get your face too close to the oven door when you opened it? That's dry heat, too, but you'll still wait six months for your eyebrows to grow back.

Doguerreotype

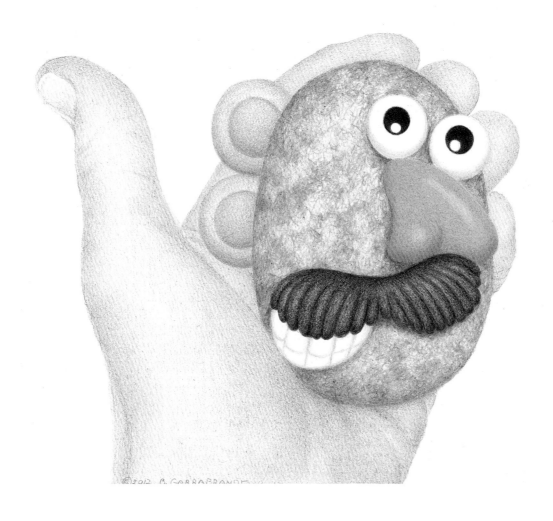

Mr. Potato Head Meets Pablo Picasso

©2012, B. GARRABRANDT

A Pointless Drawing

A Self-Help Saga

At eighteen I wandered into a bookstore and discovered *How To Be Assertive*, prominently displayed under a sign marked "New Arrivals." I took the volume from the shelf and started to browse through it. The introduction stopped me cold:

"Are you often manipulated by people?" it asked. "Made to feel guilty? Have you always 'followed the rules'?' Do you find it hard to say 'no'?"

Reading these questions was like scanning the list of symptoms for some terminal disease and realizing that I had all of them. Aggressive and manipulative people rattled me. Sure, I tossed off witty, stinging comments that put the offenders in their place, but always a day after the confrontation, with the offender long gone.

By age eighteen I had logged many hundreds of hours listening to door-to-door salesmen, fund drive volunteers, and Jehovah's Witnesses. They all loved me. They sold my name and address to solicitors everywhere. I was showered with religious tracts, magazine subscription offers, introductory encyclopedias to examine for ten days with no obligation, and volume discounts on Girl Scout cookies. It got so bad at our house that family members were instructed to tackle me to the floor whenever the doorbell rang.

In school I followed all instructions. I played it safe, right down to the proper margin width on my typed term paper pages.

While other kids grew their hair long and rebelled against authority, I grew a conservative mustache and continued to follow the rules. When a sign said "No Trespassing," I stayed out. When the words warned, "Do Not Enter," I didn't. I engaged in no stopping, no standing, and no loitering. I was a model of compliant behavior.

In the bookstore I stood and thumbed through *How To Be Assertive*, feeling a growing urge to change myself. This book was a revelation. I would stop being passive, and learn to express my feelings politely but firmly. I refused to be put down or put upon by anyone again. I felt inspired.

The manager walked up to me. He was a well-dressed, muscular man with hair closely cropped like a Marine's, his facial expression suggesting both curiosity and annoyance.

"May I help you?" he inquired.

"No, just looking," I replied.

"You've been reading that book for half an hour."

"Oh, sorry—I lost track of the time." I started to return the book to the shelf, but he blocked it with his hand.

"Aren't you going to buy the book?" he asked.

"No, not today."

"Do you think that's fair?"

"Huh?"

"In a way, it's like stealing, isn't it?"

"What do you mean?"

"You're taking the author's thoughts without compensating him."

"But I was just looking at—"

"You benefit from his experience and hard work—and he gets nothing."

"I hadn't looked at it that way," I said weakly.

"Did you ever stop to think what would happen if everyone came in here and read books without paying for them?"

"Well—I didn't think—"

"I'd be out of business." He stepped back now and studied me for a moment, then frowned. "I can understand your interest in that book," he said.

"You can?"

"I don't blame you for reading it here."

"You don't?"

"*How To Be Assertive* is an important book for a young man like you."

"You think so?"

"Yes. It builds self-esteem. You'd like that, wouldn't you?"

"Yes."

"You should buy the book."

"But I didn't plan to spend—"

"Do people ever try to make you do things you'd rather not do?"

"Well, yes."

"Would you like to keep others from taking advantage of you?"

"Yes."

"Want to feel more confident?"

"Yes."

"And learn to say 'no'?"

"Yes."

"Then you should know how to handle intimidating people."

"I guess you're right."

"A book on assertiveness training is just what you need. It will change your life."

I left the bookstore in a daze with my head spinning and a copy of *How To Be Assertive* tucked under my arm. It was Saturday afternoon. My parents were in Florida visiting relatives for a week. My brother and sister were away at college, so I spent that afternoon at home alone, reading about assertiveness:

"Never allow yourself to be exploited simply because you do not want to cause a scene," I read. "Too often people let awkward, unpleasant experiences intimidate them. Each time you retreat from a situation that calls for assertiveness, you lose a little self-respect. Your reluctance to stand up for yourself leads to increasingly passive, compliant behavior. In short, you lose control of your life."

I continued reading for hours. Hunger finally overtook my concentration late in the afternoon. I checked the freezer. It was empty. My mother had stocked up on frozen dinners before leaving for Florida, thinking that would be enough food to keep me alive until her return. But my metabolism operated at a speed high enough to break the sound barrier. My six-foot, 132-pound frame needed constant stoking.

I drove to the supermarket. My parents would be home the following evening, so I needed only a few groceries to hold me over. I picked out a T.V. dinner, a bag of potato chips, cookies, and some fruit. Then I pushed my cart down the beverage aisle and stopped at the shelves containing bottled water.

Our tap water at home tasted awful. It was well water, and smelled like rotten eggs. "It's just the minerals," my parents explained. "This water is good for you."

I wouldn't drink it. Every goldfish placed in a bowl of our tap water turned on its side in minutes, floated to the surface, and died there. Rather than see me dehydrate, my mother bought bottled water.

I glanced at a small sign taped to one of the shelves of spring water. "Save 20 Cents," it read. Great! I grabbed a gallon bottle from the shelf and inadvertently flipped the sale sign up to the next shelf, face down. I left it there.

I placed the water in my cart and noticed the price sticker on the bottle. It did not show the sale price. I bent down to examine another bottle on the shelf, then several more. All of them were stamped with the regular price. The stock boy must have forgotten to change them. "Oh well," I thought, "I'll just tell the checker."

There was no line at the "Express" checkout. As I put my groceries onto the conveyor belt, a tabloid newspaper in the rack next to me caught my attention with its huge headline, "*SINGING BABY BORN WITH TWO HEADS!*" And underneath, "Docs Amazed By 'Melancholy Baby' Harmony!" I laughed and turned to say something to the checker just as she rang up the bottled water at the wrong price.

"Excuse me," I said softly. "That water is on sale."

She looked at the price sticker, then at me. "No it isn't," she said, and continued to ring up my groceries.

"The water is twenty cents off," I told her.

She grabbed the water and held it up to my face to make her point. "The sticker on the bottle doesn't show that."

"Yes, I know," I said, "but the sign on the shelf back there says it's on sale."

The checker sighed audibly. "Wait here," she said. "I'll be right back." She left her cash register and headed toward the food aisles at a leisurely, almost lifeless pace.

"Sorry," I heard myself call after her.

A voice in my head chided me: "No need to apologize! Why should you be overcharged? This situation calls for assertive behavior!" I shifted my weight from one foot to the other with the uncomfortable feeling that I was being watched. I turned to my left. Several shoppers had joined the "Express" line. They glared at me. I looked away and reassured myself with an internal pep talk:

"Never mind those people in line. Let them stare at you if they want. You've done the right thing. It's not *your* fault the stock boy didn't price the water correctly."

My eyes searched the food aisles nervously. Where was that checker? Why was she taking so long? She should've been back by now.

I glanced down at the food items on the conveyor belt. The man next to me was buying a half gallon of ice cream. It was melting. A small puddle had formed and was spreading along the conveyor belt, threatening to encroach upon a broccoli stalk. I winced as my eyes slowly turned to the burly man standing there staring at me. I smiled sheepishly. I looked over his shoulder at the other shoppers in line. There were seven of them, all eyeing me with obvious hatred. Judging from their facial expressions, you would've thought I had asked to molest their daughters.

I turned away quickly to scan the store. "What's happened to that checker?" I wondered anxiously. "She probably slipped into the meat locker for a rendezvous with the butcher. She looks the type."

Finally I caught sight of her and watched as she made her way, slug-like, toward our checkout line.

"Welcome back," I thought. "How was your vacation?"

She resumed her position at the cash register and said smugly, "I didn't see any sale sign on the shelf."

Then I remembered. "Oh—I think I accidentally flipped the sign up to the next shelf when I lifted the water out," I told her. My words sounded painfully implausible, even to me.

The checker's stare was cold, disbelieving. I stammered to explain. "Uh—the sale sign is face down—so—uh—you can't see it." That sounded even worse.

The checker was incredulous. She cracked her gum wad at me and said nothing. The man next to me in line turned to the woman on his left.

"What is it with this kid, anyway?" he said.

"Anything to save a few lousy pennies," the woman announced loudly.

I caved in. "Oh, never mind," I said. "It's only twenty cents. Forget it."

The checker eyed me with contempt a moment longer, then turned to ring up the rest of my groceries.

Meanwhile, my inner critic launched a silent protest: "Wrong! You're letting yourself be intimidated! If the bottled water is on sale, you shouldn't pay a penny more than the sale price!"

"That's $9.08, please," the checker said, her palm outstretched before me.

I removed a bill from my wallet and gave it to her.

"Out of ten," she muttered.

"The money is unimportant," my conscience persisted. "Your self-esteem is on the line here. If you back down now, you'll lose respect for yourself. Stand your ground!"

"Your change, sir."

I took my change from the checker, dropped it into my pants pocket, and realized instantly that THIS WAS MY PAIR OF PANTS WITH THE HOLE IN THE POCKET! A sick feeling came over me as the coins slid down the length of my pant leg and I heard that awful sound of change jingling onto the floor. Did the coins roll to the right? No. Behind me? Of course not. In a moment I was down on all fours, body pointed left as I groped along the floor for my change. I weaved among the legs of the irate people in line—people who might start kicking me at any moment.

"Now I *have* to get that sale sign," I told myself. "These people think I'm an idiot. My self-respect is at stake."

I scrambled to my feet, shaking now, and said to no one in particular, "Let me go check that shelf—I'm sure there was a sale sign."

The checker and everyone in line watched dumbfounded as I headed for the beverage aisle.

At the bottled water display I stopped and searched the shelves for the sale sign. There it was! I yanked it from the shelf and read the words, "Save 20 Cents." I was vindicated! That checker probably knew all along it was there. I hurried back to "Express," pushed my way through the line, and presented the sale sign to the checker.

"Here it is!" I said, triumphantly asserting myself. "You see? I was right. The water *is* on sale!"

The checker read the sign, shaking her head in disgust. She shoved the sign back to me. "The sale is on Mountainside Spring Water," she said curtly. "You bought Lehigh Valley brand."

I blinked stupidly at the sign. "Oh—uh—yeah…I see," I stammered. "Uh—sorry."

The other shoppers in line were murmuring among themselves, no doubt plotting the best way to kill me.

I turned to leave and walked into a shopping cart. I backed up wildly and knocked into a woman carrying two bags of groceries. They flew from her arms. Canned goods, eggs, milk, and produce scattered everywhere.

I remember nothing of what happened next. There are limits to how much humiliation the human mind can withstand and still remain functional. My limit was surpassed that afternoon in the Five-Items-Or-Less line. Somehow I got out of the supermarket and back to my car alive.

I drove home knowing that *How To Be Assertive* was the wrong book for me. I would've benefited more from reading Thoreau's *Walden*. I could isolate myself in the woods, I thought, live on my own and never have to deal with pushy people again. No more unnerving social encounters, no more humbling confrontations. I would be forever free. And I would find some way to have my groceries delivered.

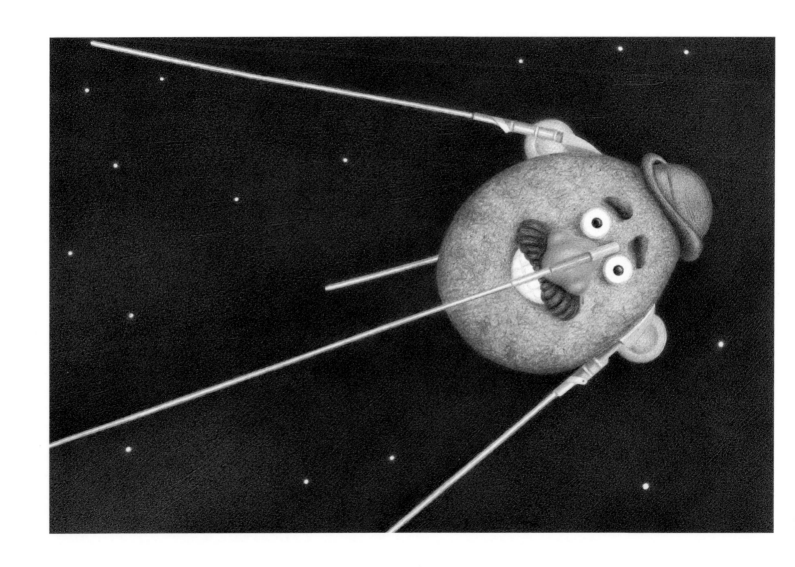

Spudnik

Bad Suspense Films

Objects In Mirror Are Closer Than They Appear

On Death

If life were a cocktail party, our human condition would not make a good conversation starter:

"Hi, where are you from?"

"I don't know."

"Well—how did you come to be here?"

"I'm not sure."

"How do you know the host?"

"Actually, I've never met Him."

"Will you be staying long?"

"Beats me."

"Where will you go when you leave here?"

"I wish I knew."

Have you ever thought about what you'd like your epitaph to be? A magazine writer in the 1930's posed this question to a number of celebrities. Comedian W.C. Fields said he wanted his tombstone to read, "On the whole, I'd rather be in Philadelphia." Humorist Dorothy Parker chose, "Pardon my dust."

Actually, a friend of mine came up with what I think is the best epitaph: "Is it just me, or does this happen to everybody?"

I told my wife I'd like my epitaph to read, "Not out of business—just relocated." When I die, I want to go the way Bing Crosby did. Finishing a round of golf, he turned to his caddy and said, "It's been a great game." Moments later he collapsed, dead.

Of course, for me the scene would differ slightly. I'm not a golfer. My last words would probably be, "What the hell am I doing here at the 18th hole?"

"Home For The Hollandaise"

Failed Christmas Carols

Bach Choy

The Milky Weigh

Mr Potato Head Takes a Fork In The Road

After 63 Years They Both Keep Their Cool

Neighbors Earl and Emma Good were married in 1950. Here is Emma posing with the refrigerator they bought together shortly before their wedding. Seven decades later, it continues to do its job!

2nd Top 12 Truths of Life

Earlier in this book I presented what I said were the top twelve truths of life. But there are so many important life truths, it's virtually impossible to narrow them down to just twelve. And so, in closing, I give you my second, "top twelve truths of life:"

12. You don't need to know what you're talking about to find lots of people who'll understand and believe you.

11. Fire hydrants get all the best parking places.

10. Matter can be neither created nor destroyed, nor can it fit in your present closet space.

9. An apple a day keeps the doctor away, but only if your aim is good and you throw it hard enough.

8. God created weather so that unimaginative people would have something to talk about.

7. Love is not a feeling. Indigestion is a feeling—love is a conscious choice.

6. Even after years of marriage, some partners are to each other what they were when they first met—total strangers.

5. Some see the glass as half empty; others see the glass as half full. Sometimes it's best to see it as a dribble glass.

4. It is unnatural for a woman to diet to the point where her hips disappear.

3. God created the aging process because He knows most people are too lazy to find their own challenges.

2. The world wasn't made in a day, but it sometimes looks that way.

1. If you can't laugh at yourself, everyone else will.

Dairieres